AMBER

AND THE ANCIENT WORLD

AMBER

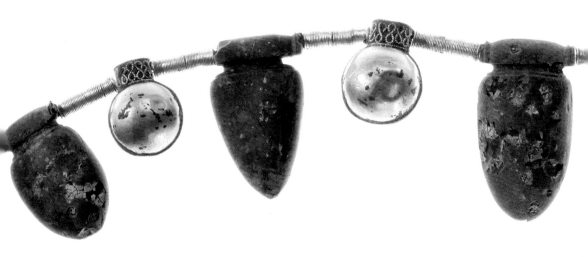

AND THE ANCIENT WORLD

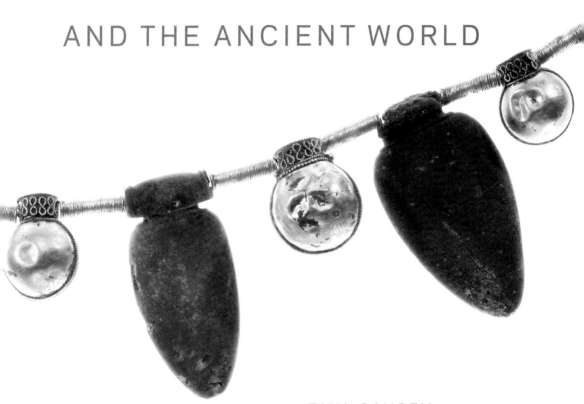

FAYA CAUSEY

THE J. PAUL GETTY MUSEUM ▪ LOS ANGELES

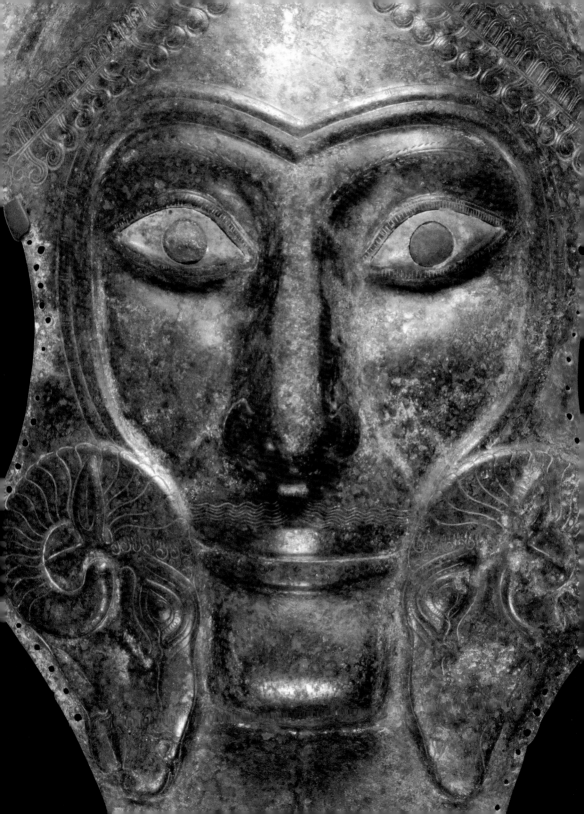

Contents

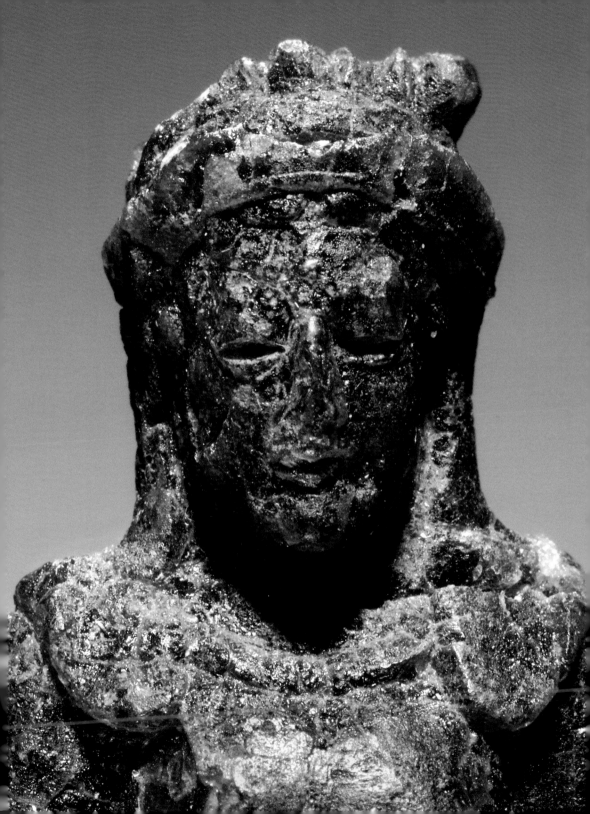

Acknowledgments

This book is based on the introduction to the online catalogue of Ancient Carved Amber in the J. Paul Getty Museum (the figured works of pre-Roman date).[1] The long period of research and writing has generated an equally long list of scholarly debts. The first and most important thanks go to the Antiquities Department at the J. Paul Getty Museum, Karol Wight, Kenneth Lapatin, Claire Lyons, and Mary Louise Hart; and to former department staff, Jiří Frel, Kenneth Hamma, Marit Jentoft-Nilsen, and Marion True. Recently, Alexandra Sofroniew, Antiquities Department intern, with keen eye and deft hand has greatly aided the transformation of the manuscript into this book and the online catalogue. In Antiquities Conservation, heartfelt appreciation goes to Jerry Podany and to former staff member Maya Elston. Michael Shilling and Jeffrey Maish of the Getty Conservation Institute provided critical scientific analysis. In the Director's office, David Bomford, Stephen Garrett, and John Walsh in turn offered support at important junctures. The beautiful photography by Ellen Rosenbery and Tahnee Cracchiola speaks for itself. Benedicte Gilman and Mark Greenberg, the original supporters at Getty Publications, are owed more than appreciative words. The book and the online catalogue are the results of the talents of the designer Kurt Hauser and the production coordinators Pamela Heath and Elizabeth Zozom. The anonymous reader offered priceless comments. Cindy Bohn, manuscript editor, deserves commendation for her skill and patience. Last, but certainly not least, without Marina Belozerskaya, guide and lantern, the project would have been benighted long ago.

Two great libraries and their staff call for special mention, the library at the National Gallery of Art Washington, my home institution, and

1 The online catalogue containing the full introduction and the complete notes can be found at http://publications.getty.edu

that of the Getty Research Institute, where I have been a Reader since it opened. Neal Turtell, Lamia Doumato, Thomas McGill, Jr., and Ted Dalziel (in Washington), and Susan Allen, Anne-Mieke Halbrook, and Susan Allen (at the Getty) represent the best in art librarianship. I would also like to recognize the help given to me over the years by the library staff of the American Academy in Rome; the University of California, Los Angeles; the University of California, Riverside; the University of California, Santa Barbara; the Sterling and Francine Clark Art Institute; and Edinburgh University.

Throughout my tenure at the National Gallery of Art, I have had superb administrative support and thank for it Rusty Powell, Alan Shestack, Franklin Kelly, Elizabeth Pochter, and Lynn Russell. The help offered by colleagues while on sabbatical in Edinburgh and during the period of an Ailsa Mellon Bruce Curatorial Fellowship at the Center for Advanced Study in the Visual Arts at the National Gallery of Art, and of a Summer Fellowship at the Sterling and Francine Clark Art Institute Fellowship greatly affected the outcome of the publications. In Williamstown, special thanks are offered to Michael Ann Holly, Mark Ledbury, and Richard Rand; in Washington, to deans past and present, Henry A. Millon, Elizabeth Cropper, Therese O'Malley, and Peter Lukehart. The grants and fellowships supporting research abroad began with a Samuel H. Kress Traveling Fellowship. Summer grants from California State University, Long Beach made possible the first Italian sojourns. Two Robert H. Smith Fellowships awarded by the National Gallery of Art were critical to research in Greek and Italian museums.

Any museum-based endeavor is a complex project, and institutions housing archaeological finds, especially fragile collections, present special challenges. I owe a debt of gratitude to the many people around the world who aided me in the firsthand study of amber objects. At museums in Argentina, Chile, Costa Rica, Croatia, the Czech Republic, Denmark, Egypt, France, Germany (once East and West), Greece, Hungary, Italy, Mexico, Russia, Serbia, Slovenia, Turkey, the United Kingdom, and the United States, curators, conservators, registrars, scientists, photographers, and other professionals were instrumental

to the research. Particular appreciation is owed to Joan Mertens and Carlos Picón of the Metropolitan Museum of Art; Denis Haynes and Dyfri Williams, of the British Museum; Alain Pasquier, of the Louvre; Mary B. Comstock, John Herrmann, and Cornelius C. Vermeule, of the Museum of Fine Arts, Boston; Jan Bouzek of the Classical Institute of Archaeology, Charles University; János György Szilágyi, Fine Arts Museum, Budapest; Elena Khodza at the State Hermitage Museum; and David Grimaldi of the American Museum of Natural History. Gavin Hamilton, Leon Levy and Shelby White, and Judy and Michael Steinhardt kindly welcomed study of their private collections. Without the generous help of specific scholars and curators in Italy, this project would not have progressed. Among Italian colleagues, I would like to extend particular thanks to Sebastiano Bianco, Nuccia Negroni Catacchio, Giulia Rocco, and Marcello Tagliente.

Substantial recognition goes to my *Doktorvater*, Mario Del Chiaro, and to my former graduate students and research assistants in California and Washington. First on the list are the Angelenos Maureen Burns, John Tucker, René Ninaber, and Anna Zagorski. Alexis Castor and Bjoern Ewalt were ideal research associates at the Center for Advanced Study in the Visual Arts. In Washington, Patrick Resing and Jack Shepherd performed key editorial work. Lee B. Ewing, photographer, National Gallery of Art, offered new insights. Amber life and work were much ameliorated by my Academic Programs Department colleagues Ana Maria Zavala Kozuch, Ali Peil, Rachel Schulze, and Jennifer Wagelie.

Without the support of family and friends, this work would not have reached daylight. Selma Holo and Fred Croton read and listened to the unfolding story. Alan Conisbee and Marie Clarke offered more than engineering insight. Grandmother and parents, Elizabeth Lees, Willard Causey, Catherine Causey-Lees, and siblings C. Andrew Causey, Douglas Causey, Kay Marie Kuder, and Laurel Nelson not only provided encouragement over the years, but also keen editorial eyes. Andrew's contributions go far beyond art and anthropology. To my son, Jan, and to the memory of Philip this book is dedicated.

AMBER AND THE ANCIENT WORLD

Amber has always fascinated mankind. Since the Paleolithic era, this ancient plant product has played a role in human life and death. Amber, the resin of several different species of trees, which metamorphosed over millions of years into a hard, transparent, plasticlike polymer, appears to be a stone (figure 1). Treasured in its raw state, made into ornaments or sewn onto clothing, amber was dedicated to divinities and used in the ceremonies of death and burial. Like the sun, amber is golden and luminous and it seems always to have been treasured for its beauty, rarity, fragrance, and inclusions of animal and plant material, caught in the ancient resin as if still alive (figure 2). For millennia, amber has been highly valued as a gemstone, as an ingredient of perfume and incense, and as medicine, both preventive and therapeutic. Its naturally occurring electromagnetic characteristics gave rise to the word for electricity (from its Greek name, *elektron*). It is no wonder that amber has been considered magical. Today, amber's age may be its greatest attraction. Although there are ancestors of amber recorded for the Permian, Triassic, and Jurassic periods, it is in the Cretaceous period that amber formed from conifers and flowering trees became abundant. Most of the major deposits of amber located throughout the world are from the Tertiary period (65 million years ago to the present). Within the Tertiary, most deposits derive from the Eocene, a few from the Oligocene and Miocene, and fewer still from the other Tertiary ages. The archaeological objects in this book are likely all carved from Baltic amber, found in European deposits dating to the Late Eocene-Early Oligocene.

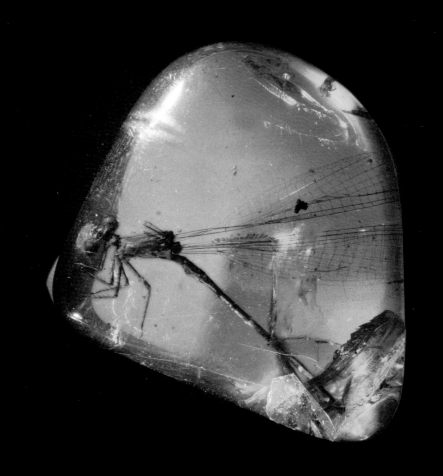

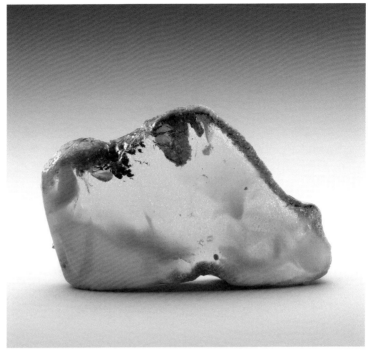

FIGURE 1
Amber with a damselfly in
Dominican amber. L: 4.6 cm
(1⅘ in.). Private collection.
Photo: D. Grimaldi/American
Museum of Natural History.

FIGURE 2
Polished section of a piece
of Baltic amber. L: 8.1 cm
(3⅕ in.). Private collection.
Photograph © Lee B. Ewing.

This book is focused on the appreciation and use of amber in the ancient Mediterranean, especially in Italy, but it ventures in many directions in an attempt to understand amber's importance in antiquity: what it was believed to be, how it was used, and why. The starting point is a small collection of carved amber objects, almost all jewelry elements, in the J. Paul Getty Museum. The earliest works date to the seventh century B.C.; the latest to the second century A.D.; all likely were once buried in the graves of the elite on the Italian peninsula.

Yet amber's use in Europe, in the Mediterranean, and in the Near East goes back much further. It is documented in human use since the Paleolithic era. Even before there was language to describe the material and its usage, amber played an important role in adornment and social distinction.[1]

The source of the amber has always been important, and myth, lore, and science have all been plumbed for the answers. Ancient authors, geographers, historians, and poets left considerable literature about the

material. Its geological and geographical origins were debated. Did it originate in the ocean, rivers, or the earth: from the far North or from ancient Syria; as the tears of mythical weeping sisters, of lynx urine, or exudations of the earth? The botanical origin remains controversial, despite a long history of investigation. We now know through scientific analysis of the resin that the great majority of amber buried in ancient Europe, Egypt, the Aegean, Near East, Greece, and Italy originated on the shores of the Baltic, and thus was traded far from its geographical origins. Tutankhamen was buried with amber beads; Aristotle studied it; Augustus was portrayed in an amber statue; and Nero decorated the Colosseum with thousands of pieces of the raw resin.

Why is so little known to the general museum visitor or reader about the role of amber in the ancient world, especially in jewelry and ornament? The main problem is the survival of amber, since it is an organic material. Archaeological amber is often degraded through oxidation, and only in rare burials has it survived looking anything like it was in antiquity. In addition, amber has not received the same scholarly treatment as have gold and silver, bronzes, or marbles. A watershed publication of more than forty years ago, the catalogue of the carved amber in the British Museum by Donald Strong, was the first to take a big view of the subject, and it is one of his thoughts that got this author stuck in amber! Strong suggested that amber carvings in pre-Roman Italy underline amber's magical aspects.[2] Since his 1966 publication, there has been considerable research on amber in the ancient world and on related subjects, and a significant number of amber-specific studies have been published during the last decade. These range from exhibition and collection catalogues, to excavation reports, to in-depth studies on individual works, to broader sociocultural assessments. Still, many finds and investigations (including excavation reports) await publication.

Only a small number of carved amber objects are on display in public collections; relatively few are published, or even illustrated; and too few come from controlled contexts. Many important works are in private collections and remain unstudied. Moreover, under some conditions

of burial, and because of its chemical and physical structure, amber has often deteriorated over time. Many ambers are friable, often difficult to conserve, and sometimes even to study; they can be handled only with great care and therefore are notoriously difficult to photograph, illustrate, or display. Much more remains to be learned about amber objects from a uniform application of scientific techniques, such as neutron activation analysis, infrared spectroscopy, isotope C_{12}/C_{13} determination, pyrolysis gas chromatography mass spectrometry (Py/GC/MS), and Fourier-transform infrared (FTIR) spectroscopy, as recent research has demonstrated.[3]

JEWELRY: NEVER JUST JEWELRY

In the ancient world jewelry, and that made of amber in particular, was never a mere ornament (figure 3). Today, throughout the world, jewelers, artisans, and merchants make or offer for sale religious symbols, good-luck charms, evil eyes, birthstones, tiaras, mourning pins, wedding rings, and wristwatches. Jewelry can signal allegiance to another person, provide guidance or serve a talismanic function, ward off danger, or link the wearer to a system of orientation—as does a watch set to Greenwich Mean Time—and to ritual observances. Birthstones or zodiacal images can connect wearers with their planets and astrological signs. Certain items of jewelry serve as official insignia, the crown jewels of a sovereign or the ring of the Pontifex Maximus, for example. A cross or other religious symbol can demonstrate faith or an aspect of belief. Not only do goldsmiths make jewelry, so do healers and other practitioners with varying levels of skill.

Jewelry is made to be worn, is often bestowed or given as a gift at significant threshold dates, and is regularly imbued with or accrues sentimental or status value because of the giver or a previous wearer or donor. In antiquity jewelry was frequently given to the gods (figure 4). Dedications might be made at the time of transition to womanhood, as the result of a successful birth, or in thanksgiving. Jewelry of gold, amber, ivory, and other precious materials might be placed on cult

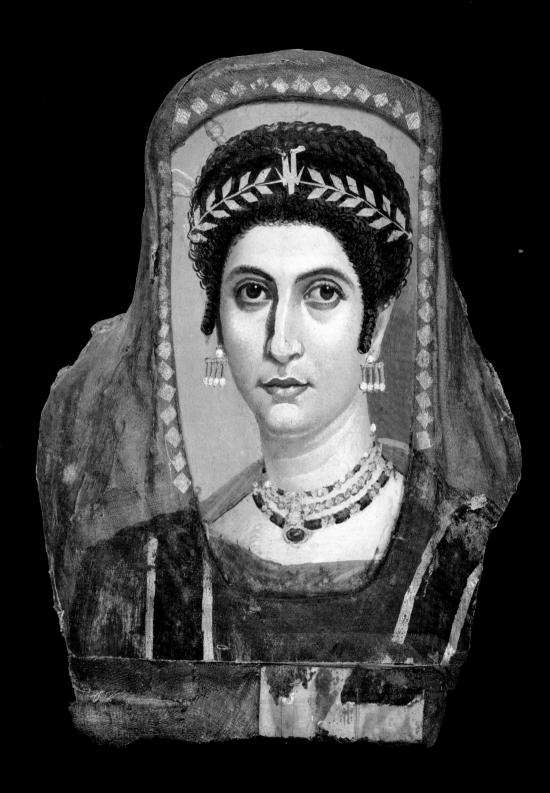

states, to form part of the statue's embellishment, or *kosmos,* to use the Greek term. In notable cases, such embellishment was later renewed and the old material buried in sanctuaries as deposits.

Underlying the following discussion of ancient carved amber is the belief that jewelry is value-laden and that its form as well as materials are powerful indicators of its owner's identity. Permanent ornaments can endure beyond one human life and connect their wearers to ancestors, thus playing a crucial role in social continuity. Perhaps more than any other aspect of the archaeological record, body ornamentation is a point of access into the culture of the past. Ethnographers see body ornamentation as affirming the social construct and, when worn by the political elite, as iterating the hierarchical structure and guaranteeing the group beliefs. Jewelry is one of the most powerful and pervasive forms in which humans construct and represent beliefs, values, and social identity.

Lifelike images in jewelry might carry magical and religious properties and may have been highly charged ritual objects in their own right. Amber ornaments carved in the form of humans, animals (figure 5), or composite creatures and buried with members of a religious or political elite may well have had such an identity.

The nature and role of amber-workers—jewelers, pharmacists, priests, "wise women," or magicians—are critical to reading body ornaments. Not only the materials and subjects, but also the technology of jewelry-making, were integral to the effect. If the materials were precious and the making mythic or magical, the results were appropriate for the elite, including the gods. The concept of maker also includes supernatural entities, such as magician-gods and other mythic artisans. In the Greek-speaking world, Hephaistos is described in the *Iliad* at work in his marine grotto, making arms, armor, *and* jewelry, elegant brooches, pins, bracelets, and necklaces. The god crafted Harmonia's necklace and Pandora's crown. Daidalos put his hand to all sorts of

FIGURE 3
Mummy Portrait of a Woman, attributed to the Isidora Master (Romano-Egyptian, act. ca. 100–125), ca. 100–110. Encaustic on wood, 33.6 cm (13¼ in.) × 17.2 cm (6¾ in.). Los Angeles, The J. Paul Getty Museum, 81.AP.42.

FIGURE 4
Ring dedicated to Hera, Greek, ca. 575 B.C. Gilded silver, Diam. (outer): 2.2 cm (⅞ in.), Diam. (inner): 1.8 cm (¹¹⁄₁₆ in.). Los Angeles, The J. Paul Getty Museum, 85.AM.264.

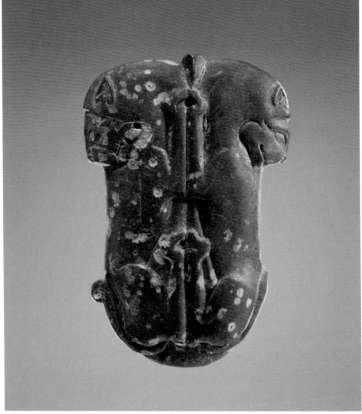

FIGURE 5

Paired Lions Pendant,
Etruscan, 600–550 B.C.
Amber, H: 5.6 cm (2⅕ in.),
W: 8.2 cm (3⅕ in.), D: 2 cm
(⅘ in). Los Angeles, The
J. Paul Getty Museum,
77.AO.81.3. Gift of Gordon
McLendon.

FIGURE 6

Amber necklaces and
gold ornaments from
the young girl's Tomb
102, Braida di Serra di
Vaglio, Italy, ca. 500 B.C.
The sphinx pendant, the
largest amber pendant, is
H: 4.6 cm (1¾ in.), L: 8.3 cm
(3¼ in.), W: 1.5 cm (⅝ in.).
Approximate total length
of strings of amber: 240 cm
(94½ in.). Potenza, Museo
Archeologico Nazionale
"Dinu Adamesteanu." Su
concessione del Ministero dei
Beni e delle Attività Culturali.
Direzione Regionale
per i Beni Culturali e
Paesaggistici della Basilicata-
Soprintendenza per i Beni
Archeologici della Basilicata/
IKONA.

creations and gave his name to what is one of the most famous of all
Greek objects of adornment, Odysseus' brooch. Many figured ambers
might have brought to an ancient Greek-speaking viewer's mind the
words *daidalon, kosmos,* and *agalma,* and specifically the *daidalon*
worn by Odysseus: a gold brooch animated with the image of a hound
holding a dappled fawn in its forepaws, the fawn struggling to flee
(*Odyssey* 19. 225–231).[4]

 This said, there is a problem with the language. The modern word
jewelry is, in the end, limiting and fails to encompass the full signifi-
cance of the carved ambers. The terms *ornament* and *body ornamenta-
tion, adornment* and *object of adornment,* too, are problematic. One of
the more accurate terms, *amulet,* is also a loaded one, as it is situated
on a much-discussed crossroads between magic, medicine, ritual, and
religion (figure 6). Amulet is a modern word, derived from the Latin
amuletum, used to describe a powerful or protective personal object

worn or carried on the person. "Because of its shape, the material from which it is made, or even just its color," an amulet "is believed to endow its wearer by magical means with certain powers and capabilities."[5] In early Greece, as elsewhere earlier in the Mediterranean world, the application of an amulet was performed in conjunction with an incantation. Incantations require skilled practitioners and receptive participants. Socrates in Plato's *Republic* lists amulets and incantations as among the techniques used to heal the sick, a tradition that continues into the Late Antique period at least. Galen, for example, sanctions the use of incantations by doctors.[6]

AMBER MAGIC?

While *magic* is probably the one word broad enough to describe the ancient use of amulets, the term is a difficult one to feel comfortable with for the modern public. As H. S. Versnel puts it, "One problem is that you cannot talk about magic without using the term magic."[7]

But even if it were possible to draw precise lines of demarcation between the ancient use of amber for adornment and its role in healing, between its reputation for warding off danger and the nature of its connection to certain divinities and cults, such categorizations would run counter to an attempt to understand amber in its wider context. How was amber as a material perceived in ancient society? How did the material itself relate to the objects into which it was fashioned? How did the objects relate to their wearers (including the deceased ones) and to the wearer's sense of the cosmos? Amber's beauty and rarity were evident to an ancient observer, but its magnetic properties, its distinctive, glowing, sunlike color and liquid appearance, its inclusions and luster, and its exotic origins were mysterious and awe-inspiring. Amber's fascination and associative value encouraged a wide range of overlapping uses. The elder Pliny, for instance, put together an impressive list of uses for amber, including its benefit as a medicine for throat problems and as a charm for protecting babies.[8] Diodorus Siculus noted amber's role in mourning rituals, and Pausanias guided

FIGURE 7
Female Head in Profile
Pendant, Italic, 500–480 B.C.
Amber, H: 4.4 cm (1⁷⁄₁₀ in.),
W: 3.8 cm (1½ in.), D: 1.6 cm
(⅗ in). Los Angeles, The
J. Paul Getty Museum,
77.AO.81.30. Gift of Gordon
McLendon.

visitors to an amber statue of Augustus at Olympia. The main sources for amber in antiquity were at the edges of the known world, and those distant lands further generated a rich lore. The myths and realities of the nature and power of amber influenced the desire to acquire it. As the historian Joan Evans has observed, "Rarity, strangeness, and beauty have in them an inexplicable element and the inexplicable is always potentially magical."[9] Beliefs about amber's mysterious origins and its unique physical and optical properties affected the way amber was used in antiquity and the forms and subjects into which it was carved.

Excavations of the last half century, especially in Italy, have greatly improved our understanding of how amber functioned in funerary contexts. The emerging picture is also enhancing our understanding of how amber objects were used *before* their burial. A number of amber pendants, including the Getty objects, show signs of wear (figure 7). Unfortunately, we can only speculate as to whether the ambers were actually possessions of the person with whom they were buried, whether they were owned by the deceased during their lifetime, how

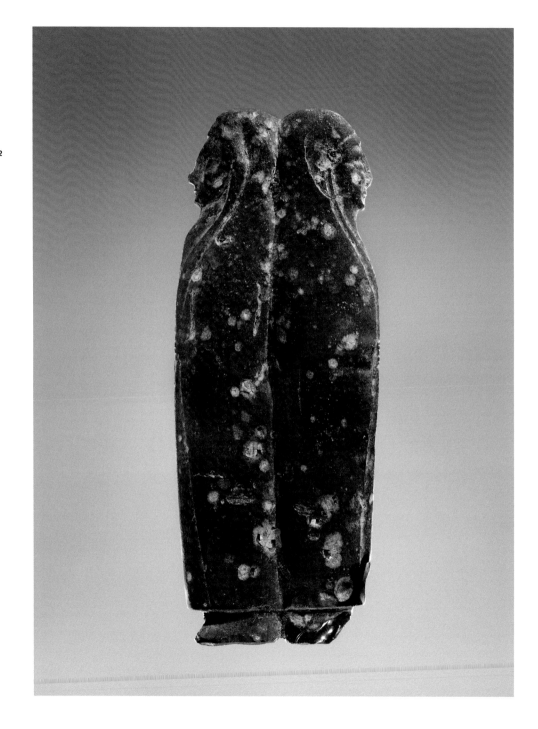

the objects were come by, in what cultic or other activity they played a part. There is no written source until Pliny the Elder, around A.D. 79, to tell us how amber was used in life (in a religious, medical, magical, or other context).[10] Only a few fragments of information from early Christian sources add to the Roman picture. All of the evidence before Pliny is archaeological and extrapolated from earlier sources—from Egypt, the Aegean, the ancient Near East, and northern Europe.[11] In Egypt, and to a lesser extent in the ancient Near East, much more is known about the how, by whom, and for whom of amuletic jewelry. In both regions, we find instances of amulets specifically designed for funerary use and of previously owned amulets continuing their usefulness in the tomb.[12]

We might also ask how amber pendants in the form of age-old subjects (goddesses [figure 8], animals, or solar and lunar symbols) relate to older traditions. Ambers in first millennium Italy were carved into *lunulae* (or crescent moons), solar signs, and female divinities and it is worth considering the possible connections with more ancient traditions. In the ancient Near East, Kim Benzel reminds us, symbolic jewelry pendants signified the emblematic forms of major deities from as early as the third millennium.

"Symbols of divinities have a long tradition of representation in various media throughout the ancient Near East. They were certainly meant to be apotropaic, but likely had far greater efficacy than the purely protective. An emblem was considered one mode of presencing a deity... The power embodied in [such] ornaments thus would have been analogous to the power embedded in a cult statue—which is perhaps why in the later religions, along with idol worship, jewels were banned."[13]

The subjects of the pre-Roman (Western Greek, Etruscan, and Italic) figured ambers vary, but without exception, they incorporate a protective as well as a fertility or regenerative aspect.[14] It is easy to see how the same amulet that had helped to ensure safe entry into the world of the living could serve a similar function in smoothing the transition into the afterworld, or world of the dead. Many images allude to a

FIGURE 8

Addorsed Females Pendant, Etruscan, 600–550 B.C. Amber, H: 4.0 cm (1⅗ in.), W: 10.2 cm (4 in.), D: 1.3 cm (½ in.). Los Angeles, The J. Paul Getty Museum, 77.AO. 81.1. Gift of Gordon McLendon.

journey that the deceased's shade, or soul, takes after death (figure 9), and are difficult to see as functioning for the living: these must have been gifts or commissions specifically for the dead. The ambers that show wear do not indicate who used them. While there is no direct evidence as to whether the amulets found in burials were owned by the deceased during life, it is tempting to assume that this could have been the case. Were they purchases, part of a dowry, heirlooms, or other kinds of gifts? Ambers were made, at some point, for someone, whether bought on the open market or commissioned to order. Inscribed Greek magical amulets (*lamellae*) "that had been commissioned for specific purposes (or most feared dangers) came to represent for their wearer a multivalent protection, a *sine qua non* for every activity in life. And in the face of the liminal dangers of the afterlife passage … this same amulet that had come to protect all aspects of life would now be considered crucial in death, the apotropaic token of the soul."[15]

The wear on many objects is undeniable. Some amber pendants are both worn and "old-fashioned" for the context in which they are found, and they cause us to remember that in antiquity there was a well-established tradition of gift giving during life and at the grave.[16] Figured ambers may have been worn in life on a regular basis for permanent protection or benefit; others on a temporary basis in crises, such as childbirth, illness, or a dangerous journey. Others may have been grave gifts or offerings to divinities, perhaps to propitiate underworld deities. In some cases, deceased girls may have been adorned as brides—a common aspect of funerary ritual.

How these objects might have functioned in reference to clanship or other social identities, either during life or during the rituals surrounding death, should also be considered. Among certain populations there may have been a generally accepted role for amber, both in the range of subjects into which it was formed and/or in the objects it embellished; some subjects may have been pertinent to clans or larger communities, in the way that shield emblazons might be. Some imagery may have been special to family groups who may have traced their origins, name, or even good fortune to a particular deity, animal, totem, or myth. If

FIGURE 9
Ship with Figures Pendant, Etruscan, 600–575 B.C. Amber, L: 12 cm (4⁷⁄₁₀ in.), W: 3.5 cm (1³⁄₈ in.), D: 1 cm (³⁄₁₀ in.). Los Angeles, The J. Paul Getty Museum, 76.AO.76. Gift of Gordon McLendon.

24

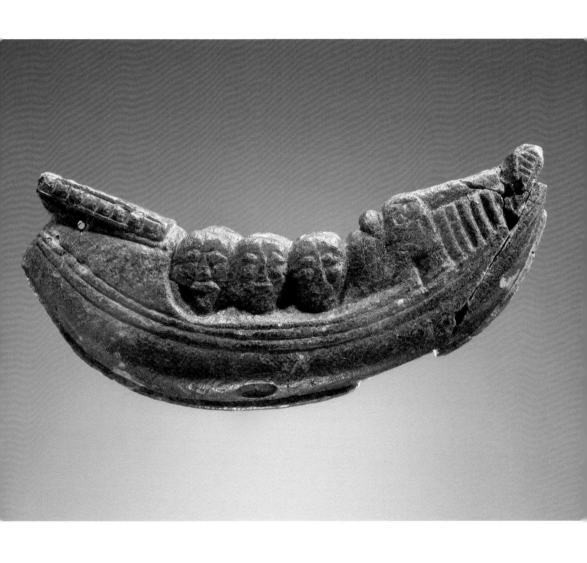

FIGURE 10
Engraved Scarab with
Herakles, Etruscan,
400–380 B.C. Banded agate,
H: 1.8 cm (¾ in.), W: 1.4 cm
(⁹⁄₁₆ in.), D: 0.9 cm (⅜ in.).
Los Angeles, The J. Paul Getty
Museum, 85.AN.123.

an elite person whose family's founder was a divinity or Homeric hero
might be buried with a ring ornamented with an engraved gem repre-
senting say, Herakles (figure 10), Odysseus, or Athena, might the same
have been true for figured ambers?

The extent to which some of these ornament-amulets would have
had a role in established cult or folk religion is difficult to ascertain,
but it should not be either exaggerated or denied. The diversity of
subjects which appear in figured amber over time suggests that the
material was used within many different symbol systems, but always
for its protective or regenerative aspects. Some pieces do incorporate
elements relating, for instance, to Dionysos or Artemis, but as such,

they occupy a hazy territory between identifiable religious practices and what Einar Thomassen calls "the appropriation of ritual power for personal ends."[17] The use of these amulets may have been dictated to some extent by skilled practitioners, but it is likely that the specific use originally intended for a protective amulet would often have eroded into a more generalized *portafortuna,* or good-luck role, over time.[18] The generally feared evil eye or *invidia*, envy, might have been warded off with any amber amulet.[19]

Worked amber and amber jewelry are well in evidence from the fourth millennium B.C. in northern Europe. The earliest evidence for worked amber in Italy is in the Bronze Age. It is not known where the amber found in graves dating to circa 1500 B.C. in Basilicata (near Melfi and Matera) was carved. In the later Bronze Age, Adriatic Frattesina, a typical emporium of the protohistoric era, was a place of manufacture. Already by this time variety in style, subject, technique, and function is evident. Some of these early ambers are the work of highly skilled artisans; others are rudimentary in manufacture and indicate work by other kinds of amber workers/amulet makers, perhaps even priest-esses, physicians, or "wise women." It is tempting to think of multiple ritual specialists involved in the working of amber and the making of amulets, perhaps in not so pronounced a fashion as in contemporary Egypt—although there is evidence for widespread amuletic usage in Italy, even into modern times. We might well envision a scenario that includes simple gem cutters as well as sculptors and multiple ritual specialists, from healers to hacks—those with fixed locations in urban settings as well as itinerants—creating amber objects. Such a variety of practitioners offering objects and ritual expertise is likely, especially for amulets in a material as inherently magical as amber.[20]

As early as the Mesolithic in northern Europe, amber was shaped into or embellished with potent symbols of the sun, fertility, and regeneration. Amber amulets shielded owners from harm, cured or prevented disease, or ensured safe passage to the hereafter. The essential characteristics of ancient amulets lie in the imagery and in the material from which they were made. Figured amulets—magical subjects carved

from a magical material—had a significance, both during life and in the grave, that reached well beyond the uses traditionally implied by the term *jewelry*.

WHAT IS AMBER?

It is important to say that amber is much studied but still not fully understood. The problems begin with the names by which the material is known—amber, Baltic amber, fossil resin, succinite, and resinite. Although these terms have all been used to describe the material of this book, they have confused as much as they have clarified. It is generally accepted that amber is derived from resin-bearing trees that once clustered in dense, now extinct forests. Despite decades of study, there is no definite conclusion as to the botanical source of the vast deposits of Baltic amber, as Jean H. Langenheim recently summarized in her compendium on plant resins:

> "It is clear that the amber is not derived from the modern species of Pinus, but there are mixed signals from suggestions of either an araucarian Agathis-like or a pinaceous Pseudolarix-like resin producing tree…Although the evidence appears to lean more toward a pinaceous source, an extinct ancestral tree is probably the only solution."[21]

Amber was originally resin exuded from the bark of trees (figure 11) to protect them by blocking gaps in the bark (although resin is also produced in the heartwood). Once resin covers a wound on a tree caused by a gash or break, or by chewing insects, it hardens and forms a seal. Resin's antiseptic properties protect the tree from disease, and its stickiness can gum up the jaws of burrowing insects.[22] In the "amber forest" the resin oozed down the trunk and branches and formed into blobs, sheets, and stalactites, sometimes dripping onto the forest floor. On some trees, exuded resin flowed over previous flows, creating layers of the material. The sticky substance collected detritus and soil and sometimes entrapped flying and crawling creatures. Eventually, after the trees fell, the resin-coated logs were carried by rivers and tides to

FIGURE 11

Amber formed on trees. In
*Tractatus De lapidus, Ortus
sanitatis* (Mainz: Jacob
Meydenbach, June 23, 1491),
sequence 776. Folio 30.2 cm
(11⅞ in.) × 20.6 cm (8⅛ in.).
Handcolored woodcut.
Courtesy of the Boston
Medical Library in the
Francis A. Countway Library
of Medicine.

FIGURE 12

Sources of Amber in the
Ancient World. Map by
David Fuller.

deltas in coastal regions, where they were buried over time in sedimentary deposits. Most amber did not originate in the place where it is found; often, it has been eroded from the soil where it was buried, perhaps at a distance from where the resin-producing trees grew, and deposited elsewhere. Most known accumulations of amber are redepositions, the result of geological activity.[23] Geologically, true amber is documented throughout the world (figure 12) with most deposits found in Tertiary period sediments dating to the Eocene, a few to the Oligocene and Miocene, and fewer still to later in the Tertiary.

Chemically, the resin that became amber originally contained liquids (*volatiles*) such as oils, acids, and alcohols, including aromatic compounds (*terpenes*) that produce amber's distinctive resinous smell.[24] Over time, the liquids dissipated and evaporated from the resin, which

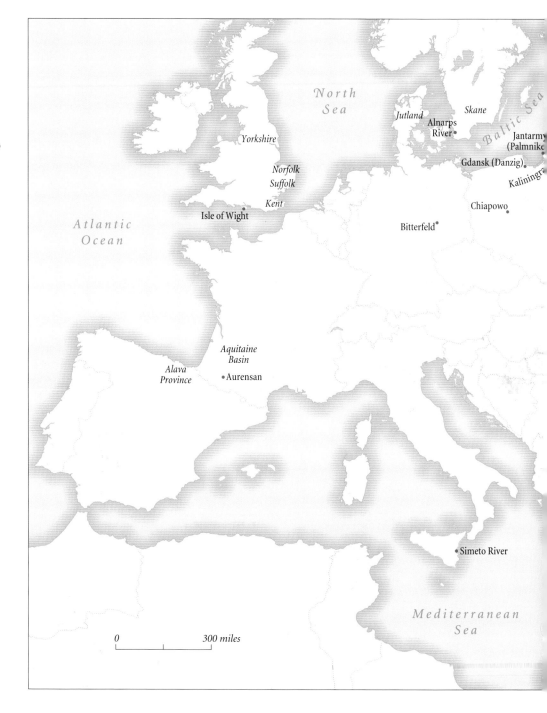

North
Sea

Jutland *Skane*
Alnarps *Jantarm*
River• (Palmnike

Gdansk (Danzig)•
Kaliningra

Yorkshire

Norfolk
Suffolk Chiapowo•

Kent Bitterfeld•

Isle of Wight•

Atlantic
Ocean

Aquitaine
Basin

Alava
Province •Aurensan

Simeto River•

Mediterranean
Sea

Baltic Sea

0 300 miles

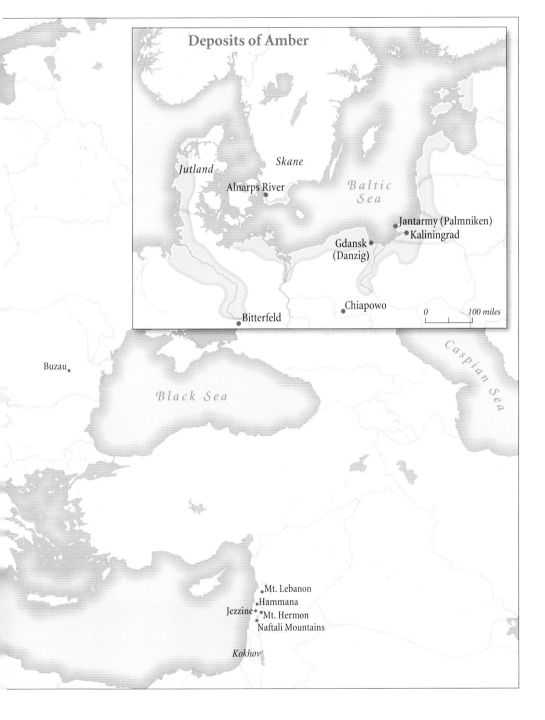

Deposits of Amber

Jutland

Skane

Alnarps River

Baltic Sea

Jantarmy (Palmniken)
Kaliningrad

Gdansk (Danzig)

Chiapowo

Bitterfeld

0 100 miles

Buzau

Black Sea

Caspian Sea

Mt. Lebanon
Hammana
Jezzine Mt. Hermon
Naftali Mountains

Kokhov

began to harden as the organic molecules joined to form much larger ones called polymers. Under the right conditions, the hardened resin continues to polymerize and lose volatiles, eventually forming amber, an inert solid, which, when completely polymerized, has no volatiles.[25] Most importantly, the resins that became amber were buried in virtually oxygen-free sediments.

How long does it take for buried resin to become amber? The amberization process is a continuum, from freshly hardened resins to those that are rocklike, and as David Grimaldi points out, "No single feature identifies at what age along that continuum the substance becomes amber."[26] Langenheim explains "With increasing age, the maturity of any given resin will increase, but the rate at which it occurs depends on the prevailing geologic conditions as well as the composition of the resin...Changes appear to be a response primarily to geothermal stress since chemical change in the resin accelerates at higher temperatures."[27]

While some experts maintain that only material which is several million years old and older is sufficiently cross-linked and polymerized to be classified as amber, others opt for a date as recent as 40,000 years before the present.[28] Much depends on the soil conditions of the resin's burial. In its final form, amber is much more stable than the original substance. Amber is organic, like petrified wood or dinosaur bones, but, unlike these substances, it retains its chemical composition over time, and that is why some experts resist calling it a fossil resin (a nevertheless useful term.)[29] In the ancient world, amber does not seem to have been considered as a fossil in the same way as were other records of preserved life—petrified wood, skeletal material, or the creatures in limestone.

Amber can also preserve plant matter (figure 13), bacteria, fungi, worms, snails, insects, spiders, and (more rarely) small vertebrates. Some pieces of amber contain water droplets and bubbles, the product of the chemical breakdown of the organic matter. It is not entirely understood how resins preserve organic matter, but presumably the chemical features of amber that preserve it over millennia are the same ones that have preserved the flora and fauna inside the amber.[30] It must be that amber's "amazing life-like fidelity of preservation...occurs

FIGURE 13
Cone in Baltic amber, L: 15.2 cm (6 in.). Private collection. Photo: D. Grimaldi/American Museum of Natural History.

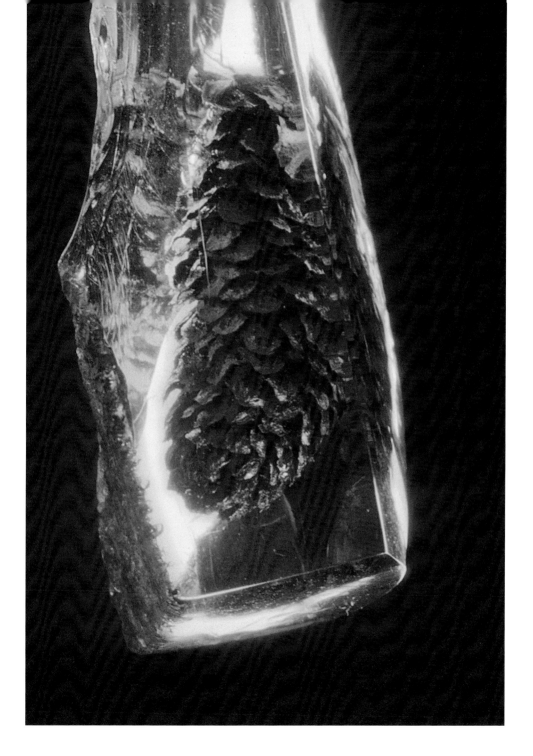

through rapid and thorough fixation and inert dehydration as well as other natural embalming properties of the resin that are still not understood."[31] The highly complex process that results in the formation of amber gave rise to a wealth of speculation about its nature and origins. Whence came a substance that carried within it the flora and fauna of another place and time, one with traces of the earth and sea, one that seemed even to hold the light of the sun?

WHERE IS AMBER FOUND?

Deposits of amber occur throughout both the Old and New Worlds, and many varieties are recognized. Of the many kinds of amber found in the Old World, the most plentiful today, as in antiquity, is Baltic amber (figure 14), or succinite (so-called because it has a high concentration of succinic acid). This early Tertiary (Upper Eocene–Lower Oligocene) amber comes mainly from around the shores of the Baltic Sea, from today's Lithuania, Latvia, Russia (Kaliningrad), Poland, south Sweden, northern Germany, and Denmark. The richest deposits are on and around the Samland peninsula, a large fan-shaped area which corresponds to the delta region of a river that once drained an ancient landmass called by geologists Fennoscandia. This ancient continent now lies beneath the Baltic Sea and the surrounding land. Although this area has the largest concentration of amber in the world, it represents a secondary deposition. Amazingly, the fossil resin "was apparently eroded from marine sediments near sea level, carried ashore during storms, and subsequently carried by water and glaciers to secondary deposits across much of northern and eastern Europe" over a period of approximately twenty million years.[32] In antiquity, most amber from the Baltic shore was harvested from shallow waters and beaches, where it had washed up (once again, millennia later), especially during autumn storms that agitated the sea beds. It is only in the early modern period that amber began to be mined. With the introduction of industrial techniques, huge amounts have been extracted since the nineteenth century. It is estimated that up to a million pounds of

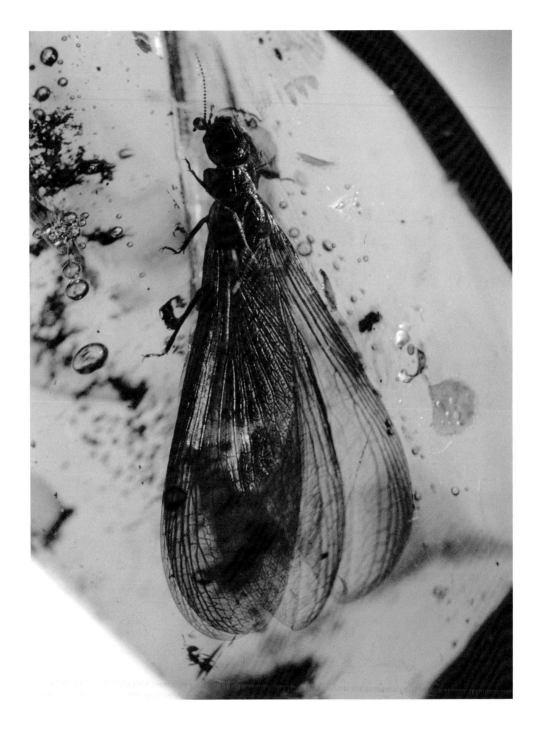

amber a year was dug from the blue earth layer of the Samland penin-
sula in the first decades of the twentieth century.[33]

Other kinds of amber used by ancient Mediterranean peoples have
been identified with sources in today's Sicily, Lebanon, Israel, and Jor-
dan. In addition to the European sources, ancient accounts mention
amber from Liguria, Scythia, Syria, India, Ethiopia, and Numidia. How-
ever, of the varieties used in antiquity and known today, only succinite
or Baltic amber is found in the large, relatively sturdy jewelry-grade
pieces such as were used for the sizable objects of antiquity, like the
pre-Roman pendants in this book, or for the complex carvings, vessels,
and containers of Roman date. Small pieces of amber and the wastage
of larger compositions could have been the source of tiny carvings and
other uses. Non-jewelry-grade amber would also have had other uses,
such as inlay, incense and perfume, pharmaceuticals, or varnish, as is
still the case in the modern period. Burmite (found in Burma, now
Myanmar), and some amber from China, types also found in large,
high-grade pieces, have long histories of artistic and other uses in Asia.[34]

FIGURE 15
Extinct termite, *Mastotermes
electrodominicus*, in
Dominican amber. L: 4.6 cm
(1⅘ in.). Photo: D. Grimaldi/
American Museum of
Natural History.

THE PROPERTIES OF AMBER

Amber is a light material, with a specific gravity ranging from 1.04
to 1.10, only slightly heavier than water (whose specific gravity is 1.00).
Amber may be transparent or cloudy, depending on the presence and
number of air bubbles (figure 15). It often contains large numbers of
microscopic bubbles, allowing it to float and to be easily carried by riv-
ers or seas. White opaque Baltic amber may have as many as 900,000
minuscule bubbles per square millimeter and will float in ordinary
water. Clear Baltic amber will sink in ordinary water but is buoyant in
saltwater. Baltic amber has some distinguishing visual characteristics
rarely found in other types of amber: it commonly contains tiny hairs
that probably came from the male flowers of oak trees, and tiny pyrite
crystals often fill cracks and inclusions. Another feature found in Baltic
amber is the white coating partly surrounding some insect inclusions,
formed from liquids that escaped from the decaying insect's body.[35]

Amber's hardness varies from 2 to 3 on the Mohs scale (talc is 1 and diamond 10). This relative softness means that amber is easily worked. It has a melting point range of 200 to 380° C, but it tends to burn rather than melt. Amber is amorphous in structure and, if broken, can produce a conchoidal, or shell-like, fracture. Amber is a poor conductor and thus feels warm to the touch in the cold, and cool in the heat. When friction is applied, amber becomes negatively charged and attracts lightweight particles—like pieces of straw, fluff, or dried leaves. Its ability to produce static electricity has fascinated observers from earliest times. Amber's magnetic property gave rise to the word *electricity*—because amber (Greek, *elektron*) was used in the earliest experiments on electricity.[36] Amber's natural properties inspired myth and legend and dictated its usage.

Before the development of colorless clear glass, a complex technique perfected in the Hellenistic period, the clear materials known in antiquity were natural ones: water and some other liquids, ice, boiled honey and some oils, rock crystal, some precious stones, and amber.[37] Transparent amber is a natural magnifier and, formed into a regularly curved surface and given a high polish, it can act as a lens.[38] A clear piece of amber with a convex surface can concentrate the sun's rays. One ancient source suggests that such a polished amber was used as a burning lens.

Once cleaned of its outer layers and exposed to air, the appearance of amber—its color, degree of transparency, and surface texture—will eventually change. As a result of the action of oxygen upon the organic material, amber darkens—a clear piece will become yellow; a honey-colored piece will become red, orange-red, or red-brown, with the surface progressively becoming more opaque (figure 16).[39] Oxidation commences quite quickly, starting at the surface, which is why some amber may appear opaque tan or brown on the surface and translucent at breaks or when lit with strong light. However, the progress of oxidation is variable and depends on the time of exposure and other factors, such as the amount and duration of exposure to light. In archaeologically recovered amber, the state of the material is dependent upon the burial

FIGURE 16
Two typical pieces of Baltic amber. Pale yellow amber was preferred by the ancient Greeks and Etruscans. Opaque orange amber was especially fashionable in Imperial Rome. L: (yellow amber): 5 cm (2 in.). L: (orange amber): 9 cm (3½ in.). Private collection. Photograph © Lee B. Ewing.

conditions, and the degree of oxidation can vary widely. The breakdown of the cortex causes cracking, fissuring, flaking, chipping, and, eventually, fractures. Only a very few ancient pieces retain something of their original appearance, in each case because of the oxygen-free environments in which they were buried. For instance, two fifth-century female head pendants that were excavated at waterlogged Spina are remarkable for their clear, pale yellow color (figure 17).[40] A large group of seventh-century amber-embellished objects from the cemeteries of Podere Lippi and Moroni-Semprini in Verucchio (Romagna) were preserved along with other perishable objects by the stable anaerobic conditions of the Verucchio tombs, which had been sealed with a mixture of water and clay (figure 18).[41] Various colors and degrees of transparency are in evidence, from pale clear yellow, to clear orange or red, to opaque yellows, oranges, reds, and tans. Inclusions are common.

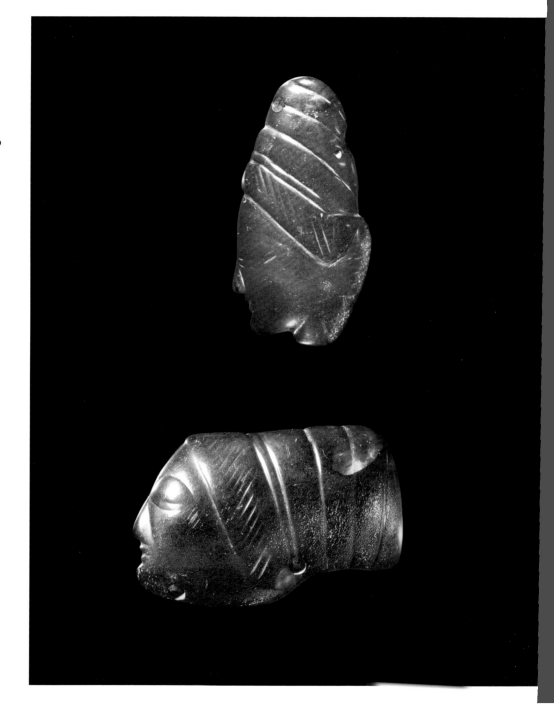

Many pre-Roman figured ambers exploit the transparency of the material, offering the possibility of reading through the composition: the back is visible (blurrily) from the front and vice versa. This is a remarkable artistic conception, iconographically powerful and magical. Two extraordinary examples are the Getty *Lion* (figure 58) and the British Museum *Satyr and Maenad* (figure 19).[42] From the top, the underside of the lion can be discerned. In the multi-group composition of the London amber, the large snake on the reverse appears to join in the reveling with the figures on the front.

FIGURE 17

Female Head Pendants, from Tomb 740 B, Valle Pega, Spina, from a tomb dating to the end of the 5th century B.C. Amber, H: 4.8 cm (1⅞ in.), W: 2.8 cm (1⅛ in.), D: 1.2 cm (½ in.) and H: 4.5 cm (1¾ in.), W: 2.8 cm (1⅛ in.), D: 1.4 cm (½ in.). Ferrara, Museo Archaeologico Nazionale, 44877 and 44878. Ferrara, Museo Archeologico Nazionale/IKONA.

FIGURE 18

Earrings, from Tomb 23, Podere Lippi, Verucchio, first half of the 7th century B.C. Amber and gold, Diam. (amber, max): 6 cm (2⅜ in.). Verucchio, Museo Civico Archeologico, 8410-850. Verucchio, Museo Civico Archeologico/IKONA.

A number of seventh-century Greek, Etruscan, and Campanian objects have the amber set into precious metal mounts or backed with silver or gold foil.[43] Some are internally lit by foil (tin?) tubes. Amber's glow, its brilliance and shine, would be immeasurably enhanced in this way.[44] Simply shaped amber pieces set into gold and silver are mirror-like, emanating radiance and banishing darkness.[45] Amber faces once mounted on polished metal, such as the Getty *Heads of a Female Divinity or Sphinx* (figures 20 and 48) might even seem to issue light, like the principal astral bodies, or capture the shimmering of light on water.[46]

42

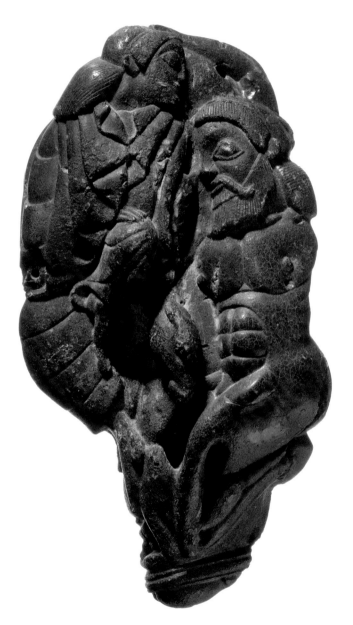

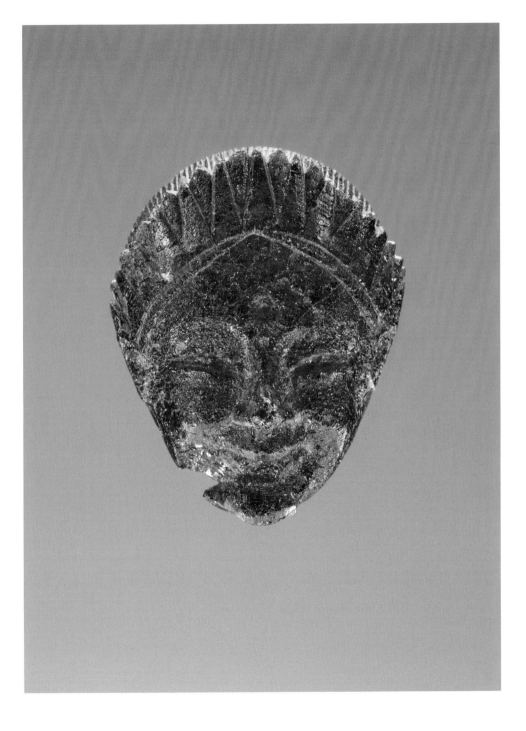

ANCIENT NAMES FOR AMBER

The words used for amber in antiquity are often suggestive not only of the qualities for which it was valued but also of the theories of its origin and the uses to which it was put. Today, although amber is still widely sought for jewelry, magic, and medicine, its floral and faunal inclusions may be its greatest attraction (as reflected in the title of the 1996 exhibition and book *Amber: Window to the Past*). There is scarce textual evidence before Roman times to indicate an ancient fascination with the interred creatures and plant remains within amber; however, its use in burials may be evidence enough.

The standard Greek word for amber was *elektron*.[47] The derivation of this word is uncertain, although scholars have suggested that it may have connections with *helko*, meaning "to draw or attract," or with *aleko*, meaning "to ward off evil."[48] The word is certainly associated with *elektor*, used in the *Iliad* to mean "the beaming sun,"[49] and is most likely derived from an Indo-European verb with the root-meanings "brilliant" or "to shine." This quality of beaming, or reflecting the sun, is also suggested by the Germanic word for amber, *glaes* or *glese*, recorded in some ancient Latin sources as *glaesum*, the same word that was used in the period for glass.[50] The Indo-Germanic root for this word, **ghel*, means "lustrous, shimmering, or bright" and gives us words like glisten, glitter, glow, and yellow in English. The current German word for amber, going back to thirteenth-century Middle Low German, is similarly evocative: *Bernstein* means burning stone.[51]

When the elder Pliny or one of his contemporaries admired a valuable piece of amber, the first thing to strike their eyes would have been the suggestion of fire (*imagine igneam*) or the material's gentle glow (*mollis fulgor*). The color of the amber was certainly evocative—of wine, honey, wax, embers, or fire—but its color was of secondary importance to its shine. This glow had been the defining characteristic of amber for centuries.

Brilliance in amber, in ice, in rock crystal, or in any stone, was only possible because of its transparency. The ancients believed that this was possible because light was *let* through it: the transparent materials thus had performative powers.[52] The brilliance of amber, enhanced by the rich connotations of its names, ensured it a place in ancient literature alongside other rare, prized, and luminous materials—sight-arresting materials like gold, silver, and ivory, whose magnificence was often associated with something beyond the merely human, with the heroic or divine.[53] In the biblical Ezekiel's vision, the metaphor for brightness is amber: "Then I beheld, and lo a likeness as the appearance of fire: from the appearance of his loins even downward, fire; and from his loins even upward, as the appearance of brightness, as the colour of amber." (Ezekiel 8.2). This association is evident from the first extant occurrences of *elektron* in Homer's *Odyssey*.[54] When Telemachus visits Menelaus' palace in Book 4, he is awestruck: "Mark the flashing of bronze throughout the echoing halls, and the flashing of gold, of amber, of silver, and of ivory. Of such sort, methinks, is the court of Olympian Zeus within, such untold wealth is here; amazement holds me as I look."[55] It is the flashing of the jewels, more so than the jewels themselves that puts Telemachus in mind of Zeus; the word he uses is *steroph*—the flash of a lightning bolt. Telemachus' association of the brightness, the shine, the *brilliance* of Menelaus' palace with divinity seems almost instinctive.

Elektron occurs two other times in the *Odyssey*; once in Book 15, when the swineherd Eumaeus, telling the story of his kidnapping to Odysseus, remembers the cunning Phoenician mariner who turned up at his ancestral home with an eye-catching golden necklace, strung with amber pieces.[56] In addition, in Book 17, when the suitors vie with

each other in the extravagance of their gifts to Penelope, Eurymachus' contribution is "a richly crafted necklace of gold adorned with sun-bright amber" (figure 21).[57] Another early occurrence of *elektron* is in the Pseudo-Hesiodic *Shield of Herakles*. In this passage, as in Homer's description of Menelaus' palace, amber takes its place in a list of rare and precious materials—to dazzling effect: "He took his glittering shield in his hands, nor had anyone ever broken it or damaged it with a blow; it was a marvel to see. The whole orb glowed with enamel, white ivory, and amber, and it shone with gleaming gold."[58]

In each of these passages referring to the use of amber—the ornamentation of a seemingly Olympian palace, necklaces intended for elite women, and the shield of a hero—amber is inextricably bound up with the light of the sun, and it is associated with gods, heroes, and a social elite. The reflection of sunlight, in the halls of a king or on the armor of a hero, was a powerful reminder of the heavens and the heavenly; brilliance and luster were primary qualities to be looked for in a precious material like gold, ivory, silver, or amber. The brilliance of the amber and other materials in Herakles' shield, combined with the perfect craftsmanship that it represented, calls attention to its *poikilia*, the adornment and embellishment all fine works should display, and made it a *thauma idesthai*, a "marvel to behold"—what Raymond Prier has defined as "an intermediation between the polarities of men and gods, visually linguistic symbols of power."[59]

Although the most common, *elektron* was not the only Greek name for amber. It is likely that the substance referred to as *lyngourion* (there are other variants of the spelling; *liggourion,* for example) was a form of amber. Its derivation and its relationship to amber (*elektron*) were much discussed in antiquity and continue to be a subject of debate today. The earliest evidence for *lyngourion* is in Theophrastus' late fourth-century lapidary, where he notes similarities between *lyngourion* and *elektron*, but does not consider them the same material.[60] He seems to have had direct knowledge of some amber, which was dug up in Liguria and which he apparently considered a nonorganic substance. Theophrastus' *lyngourion* is as hard as amber, which he includes among

FIGURE 21
Necklace with a Pendant Scarab, Italic or Etruscan, 550–400 B.C. Amber, gold, and carnelian scarab, L: 39.5 cm (15⁹⁄₁₆ in.). Los Angeles, The J. Paul Getty Museum, 77.AO.77.1.

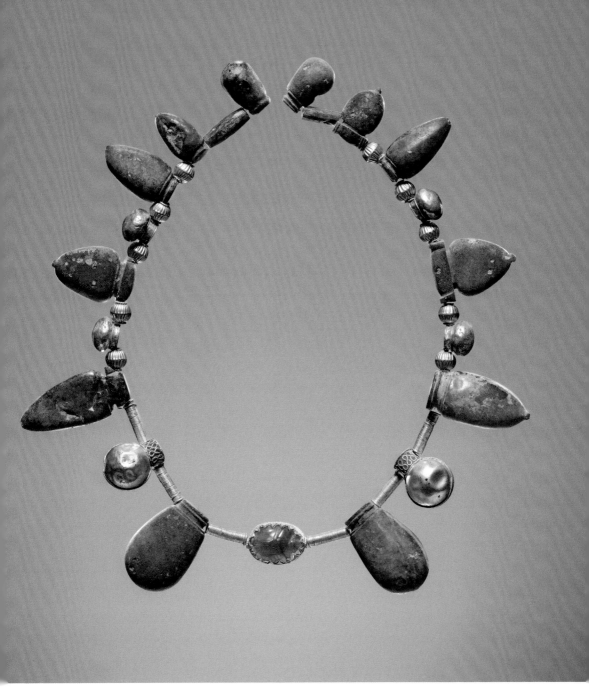

stones possessing a power of attraction, and possesses the same powers of magnetism but, according to him, has a different origin—it is the hardened urine of wild lynxes (figure 22), which "is discovered only when experienced searchers dig it up."[61] This origin story is doubtless the result of a fanciful attempt to explain the etymology of the word (*lyngourion* = lynx urine), a story that would have been additionally convincing because of the color of the substance.

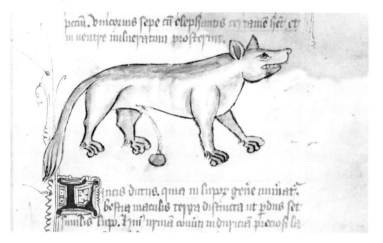

FIGURE 22

Lynx urine hardens into a stone. In *Bestiarius* GKS 1633 4°, 6r, English, 15th century. Parchment, H: 21 cm (8¼ in.), W: 13.5 cm (5³⁄₁₀ in.). Courtesy of The Royal Library of Denmark.

It was probably another attempt at etymology that persuaded Strabo that excessive quantities of amber were to be found in Liguria.[62] Strabo makes no distinction between *lyngourion* and *elektron* and uses the terms interchangeably. The elder Pliny is as unimpressed with Strabo's talk of Liguria as he is with the lynx urine story. Pliny lists a variety of sources containing variations on one or both of these themes, but his final word on *lyngourion* is that "the whole story is false, and no gemstone bearing this name has been known in our time." Although Pliny may have been justified in his skepticism (Liguria was no more a producer of amber than the lynx was of gemstones), *lyngourion* appears to be a term applied to highly transparent varieties of amber, while *elektron* was used more generally. Gemstones of *lyngourion* are first attested in third-century inventories of the Asklepeion on the south slope of the Acropolis and in the shrines of Artemis and the Eileithyia (goddesses associated with childbirth, light, and the moon) at Delos.[63]

Six other terms for amber occur in Pliny's treatise: he cites Philemon as referring to a white, waxen form of amber from Scythia as *electrum*, and a tawny colored variety (from another part of Scythia) as *sualiternicum*. Pliny also attributes to his contemporary Xenocrates of Aphrodisias the claim that *sucinum* and *thium* are the Italian words for amber and *sacrium* the Scythian word. Nicias, Pliny tells us, says that the Egyptians called amber *sacal* (perhaps meaning simply "rock"), and that the Syrian word was *harpax* (because of its magnetic qualities; the Greek *harpax* means "a thief" or "one who snatches").[64] Pliny also singles out Callistratus as the first to distinguish *chryselectrum*, or "gold amber."[65] Dioscorides, in his first-century *Materia Medica*, describes two types of amber: *elektron chrysophoron* (golden amber) and *elektron pteruyophoron* ("because it draws feathers to it"); and he uses the word *aigeiros*, which means "poplar," as a synonym for amber.[66] The poplar is not only associated with Herakles (the hero brought back poplar branches from the underworld) but also with the tale of Phaethon—the most prevalent myth about the origin of amber (see below). Some authors, like Pliny, use more than one term for the material, depending on the context.

COLOR AND OTHER OPTICAL CHARACTERISTICS: ANCIENT PERCEPTION AND RECEPTION

We may imagine that when Zeus revealed his true form to Cadmus' daughter Semele at her rash request, his own blinding brilliance would have been enough to reduce her to ashes even if he had left his thunderbolts behind. The name *Zeus* has associations of luminosity (it is derived from a word that means "to shine"), as do many of the common epithets for Greek deities: *Phoebus* Apollo means "radiant Apollo," and the goddess Athena is often described in Homer as *glaukopis*—which can be translated as "with gleaming eyes." Apollo appears to his worshippers at Delphi in a blaze of flame and brilliant light in the Homeric *Hymn to Apollo*. Similarly, the great heroes of ancient Greece are often depicted with a bright glow about them—like Achilles in the *Iliad*, "shining in all his armor like the sun."[67]

In Quintus Smyrnaeus' fourth-century A.D. *The Fall of Troy*, the mourners at Ajax' funeral laid "gleaming gold" and "lucent amber-drops" around his body.[68] This connection between the radiance of precious jewels and the brilliance of heroes and gods was established in Greece as early as Homer. Given the strong associations between the dazzling, the divine, and the heroic, the choice of amber for a piece of jewelry, or a work of art, had a particular meaning. For example, Pausanias mentions in his *Description of Greece* the amber statue of the emperor Augustus.[69] The image must have been a "marvel to behold."

When amber was considered in terms of its hue (instead of its brilliance) the images it evoked were no less striking. The most sought-after pieces ranged from yellow to red (figure 23)—colors that were

FIGURE 23
Hove tumulus cup, Wessex culture, Bronze Age. Amber, D: 8.9 cm (3½ in.). Courtesy of Royal Pavilion & Museums, Brighton & Hove.

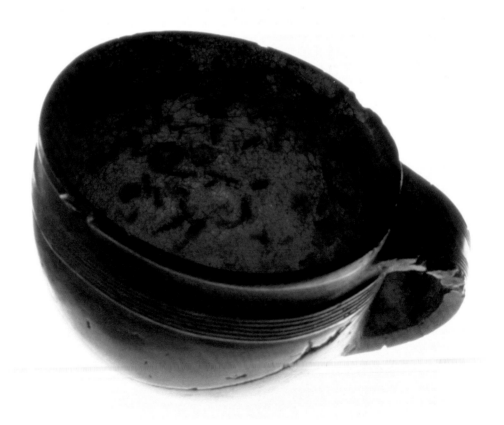

50

also associated with fire and the precious metal gold.[70] The fiery and glowing colors were important to life, marriage, and death and were linked with divine forces. Yellow and red were redolent of fire (and consequently the sun), of light itself, and were symbolic of life and regeneration.[71] In the Roman writings of Martial and Juvenal, gold was often referred to as being red.[72] And since Homer, amber and gold had been paired, and both were symbols of the sun.

The various images that the color of a gemstone conjured up could sometimes, as in the case of *elektron*, determine its name. As we noted, etymologically, the word is probably connected with *elektor*, "the beaming sun," the root meaning being "brilliant." Pliny, for instance, talks about a variety of jasper, which was called *boria* (meaning "northern"), "because it is like the sky on an autumn morning."[73] And when Pliny comes to discuss the different colors of amber, his terminology is almost invariably metaphorical. "The pale kind," he writes, "has the finest scent, but, like the *waxy* kind, it has no value. The tawny is more valuable and still more so if it is transparent, but the color must not be too *fiery*; not a fiery glare, but a mere suggestion of it, is what we admire in amber. The most highly approved specimens are the '*Falernian*,' so called because they recall the color of the wine; they are transparent and glow gently, so as to have, moreover, the agreeably mellow tint of honey that has been reduced by boiling."[74]

The metaphorical resonance of the different colors associated with amber, like the divine and heroic associations of its brilliance, would doubtless have played an instrumental role in the kinds of subjects carved in amber and in its use. In ancient gemstones, a correspondence between color and subject was desired. According to an ancient epigram, a sea nereid was cut into an Indian beryl because the blue color of the stone was appropriate for Galene, the personification of the calm sea.[75]

Amber's fragrance—it is the only "stone" which is both shining and fragrant—would be enhanced through rubbing.[76] Amber would be a perfect material for a divine image, especially when we recall that "statues were regularly polished with perfumed oils, perhaps matching

the emanation of fragrance that forms so regular a part of divine epiphanies."[77] Not only the fragrance, but the great age of the material, its mysterious origins, its transmuted nature, its electromagnetic, optical, and other properties, as well as its divine and heroic epithets would have evoked a variety of ideas in its beholders—radiant Apollo, the fiery sun, Olympian honey, Falernian wine.

FIGURE 24
Baltic amber encrusted with barnacles. L: 8.6 cm (3⅜ in.). Photo: D. Grimaldi/American Museum of Natural History.

ANCIENT LITERARY SOURCES ON THE ORIGINS OF AMBER

Where did amber come from? Attempts to answer this question, from the early Greek poets to Late Antique authors, were made in a wide variety of disciplines—philosophy, poetry, history, natural science, and even pharmacology. But the most important, and the most varied, answers came from approaches to the question that were scientific (amber comes from tree sap or lake mud or the sea), geographical (amber comes from the northern ocean, Liguria, or Ethiopia), or mythological (from the tears of Phaethon or of Meleager's sisters). However diverse are the various origin stories, they either explain amber as being related to the sun or the planets, or as being "of water" or "of earth." This difference in beliefs about amber's origin appears to have affected the very way it was used.

Pliny's chapters on amber in his encyclopedic *Natural History* are the most extensive surviving ancient source. Compiling his work at a time when amber was beginning to flood into Rome, he provides a survey of the stories then in circulation about the formation of amber, its geographical and mythical origins, the way it was classified and used. The depth and complexity of the information that was available to Pliny is striking. There was evidently a varied and lively debate about what amber was and where it came from by the time he was writing, right down to the question of whether it was a vegetable, mineral, or faunal product. Throughout Book 37, Pliny comments critically on his source material, contrasting its validity with current evidence. He passes over accounts that range from the theory that amber was moisture from the sun's rays, to the hypothesis that it was produced by heated lake mud,

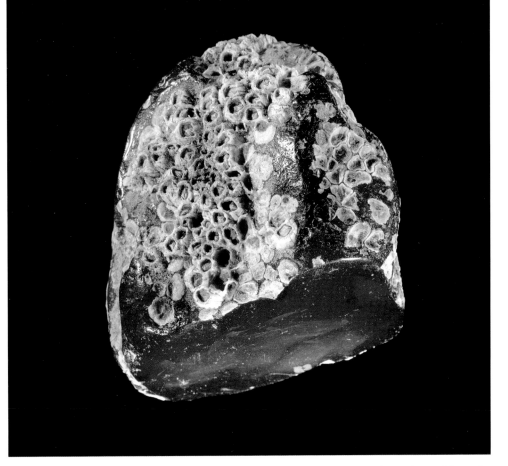

before offering his own scientific conclusions: amber is formed from the sap of a species of pine, which, hardened either by frost, heat, or the sea, "is washed up on the shores of the mainland, being swept along so easily that it seems to hover in the water without settling on the sea bed."

In many of these accounts (including Pliny's own) the sea and rivers play an important role in the manufacture of amber. This is probably due in part to the preponderance of amber that was found washed up on the shore, and it may have been fortified by a belief, prevalent in early northern solar cults, that the sun (which is another commonly recurring theme in amber-origin theories) passed through the waters of the earth on its nocturnal path. And, then as now, sea-origin amber is often encrusted with shells (figure 24).

But where, *geographically*, did amber come from? Pliny's sources do not agree. Italy, Scythia, Numidia, Ethiopia, Syria, and "the lands beyond India" are among the suggestions. Pliny himself gives preference to those accounts that place amber's origins in the north of Europe: "It is well established," he writes, "that amber is a product of islands in the Northern Ocean." Herodotus was less sure: "I do not believe that there is a river called by foreigners Eridanus issuing into the northern sea, whence our amber is said to come, nor have I any knowledge of Tin-islands...this only we know, that our tin and amber come from the most distant parts."[78]

The Eridanus River to which Herodotus refers was originally a mythical river that came to be associated with the Po and sometimes with the Rhone, among other locations. In the ancient sources the Eridanus migrates about the map. Pliny's comment on the confusion of his sources about the location of the Eridanus is typically pointed: "Such statements only make it easier to pardon their ignorance of amber when their ignorance of geography is so great." The most likely explanation of this confusion is that the Eridanus at some point became connected in myth to memories of an early land–riverine amber route running from the Baltic to northern Italy.

Herodotus himself affirms the existence of an exchange route running from the far north all the way to the Aegean. In his discussion of the Hyperboreans (a legendary race from the far north who worshipped Apollo), he mentions "offerings wrapt in wheat straw," which they bring to Scythia, and which are passed from nation to nation until they reach Delos (Apollo's birthplace).[79] You cannot reach the Hyperboraeas either by land or sea, says Pindar (*Pythian* 10.29); and most stories of travel to and from this region involve flight. Sunlike amber from the place of perpetual sun would be precious indeed.

There is something otherworldly as well as northerly about the Hyperborean's land.[80] Scholars are undecided as to whether the offerings Herodotus mentions were actually amber, but it is likely that amber was transported on such a route. Furthermore, Apollonius of Rhodes (whose answer to the question "Where does amber come from?" is a

mythological one) provides a link between amber and the cult of Apollo in his *Argonautica*. He refers to a Celtic myth that drops of amber were tears shed by Apollo for the death of his son Asclepius when he visited the Hyperboreans.[81] That amber should come to be associated with Apollo is not surprising, given its connections with the sun, but it is significant that it should occur specifically in the context of the mourning of Asclepius. Amber's role in mourning, evidenced by its funerary use (see above), is constantly emphasized in mythology. There is an explicit connection between this mythology and the funerary use of amber in Quintus' *Fall of Troy*. At the lavish funerals of Ajax and Achilles, the mourners heaped drops of amber on the bodies. For Achilles,

> Wailing captive women brought uncounted fabrics
> From storage chests and threw them upon the pyre
> Heaping gold and amber with them.

For Ajax,

> Lucent amber-drops they laid thereon
> Tears, say they, which the Daughters of the sun,
> The Lord of Omens, shed for Phaethon slain,
> When by Eridanus' flood they mourned for him.
> These for undying honour to his son,
> The God made amber, precious in men's eyes.
> Even this the Argives on the broad-based pyre
> Cast freely, honouring the mighty dead.[82]

By Quintus' time, the tale of Phaethon had long been the preeminent myth associated with amber.[83] The name Phaethon, meaning "the shining one" or "radiant one," derives from the Greek verb *phaethô*, "to shine." (And so, too, did the Greeks call the sun "Elector" or "the Shining One").[84] The Phaethon story, which provides a classic example of hubris followed by nemesis, was first recorded by Hesiod, and dramatized in Euripides' mid-fifth-century *Phaethon*, but might be best known today from Ovid's version in the *Metamorphoses*.[85]

According to Ovid, Phaethon was the son of Clymene and the sun god Helios. As an adolescent, he doubted his parentage and voyaged

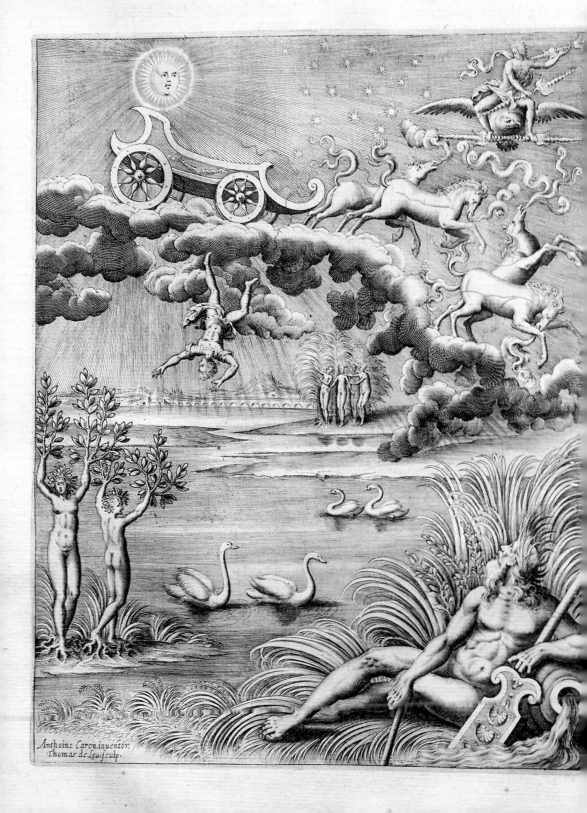

Anthoine Caron inuentor.
Thomas de Leu sculp.

to the East to question his father. There the god welcomed his son and promised as proof of his paternity to grant any boon he might ask. The youth rashly demanded permission to drive the sun chariot through the sky for one day. So unsuccessful and dangerous was the young charioteer that Zeus was forced to kill Phaethon with a thunderbolt in order to save the world from destruction. The result was a disastrous cosmic fire. The youth's flaming body fell into the legendary Eridanus River. His sisters, called the Heliades (daughters of Helios), stood on the banks of the river weeping ceaselessly for their brother, until they were finally changed into poplars (figure 25). Thereafter the tears of the Heliades fell as drops of precious amber onto the sandy banks, to be washed into the river, and eventually borne off on the waters "to be an ornament one day for Latin girls." Phaethon's friend Cygnus, the king of Liguria, was so distressed that he left his people to mourn among the poplars and was eventually transformed himself—into a swan.

As in the Celtic myth about Apollo mourning Asclepius, Phaethon's tale is one of a young life tragically cut short. When Diodorus Siculus tells the Phaethon story in his *Library of History*, he ends by pointing out that amber "is commonly used in connection with the mourning attending the death of the young."[86] But as well as reminding us of amber's role in mourning, the poplars dropping tears into the river are evidence that there were theories connecting amber to tree resin as early as the fifth century (which marks the first extant occurrence of the Phaethon myth). The link between resin drops and tears is a natural one; myrrh, for instance, is explained in myth as the tears of Myrrha, who was changed into a tree for her crimes—indeed the Greek word for tear, *dakruon*, can also mean sap, or gum (meaning resin). A broader trend in mythology (in many other cultures as well as the Greco-Roman) connects precious stones generally to tears, and mythological accounts of amber's origin do not always involve trees. Pliny refers to a (now lost) play by Sophocles that links amber to Meleager, the famous hero of the Calydonian boar hunt.[87] According to one version of the myth, Meleager's sisters, who were changed into birds (*meleagrides*, perhaps guinea fowl) by Artemis when he died, migrate

yearly from Greece to the lands beyond India and weep tears of amber for their brother. Artemis' role is a critical one in this story, considering the number of amber carvings that might be associated with her. While one Late Antique author places the Meleagrides on the island of Leros, opposite Miletos, Strabo sets the transformed birds at the mouth of the Po or south of Istria—locations of great interest considering the number of seventh-century ambers in the form of birds excavated from sanctuaries and graves in both Greece and Italy.

Another amber-origin story, recounted by Pseudo-Aristotle in *On Marvelous Things Heard*, is intriguing for its hint at connections between amber, sun myths, and metalworking, and for the presence of figured amber and Greek artists at the mouth of the Po River.[88] Ever present in these accounts is the sadness of a youth's early death, and this version involves Icarus, who was burned flying too close to the sun. According to Pseudo-Aristotle, Icarus' father, the master craftsman Daedalus, visited the Elektrides ("amber islands"), which were formed by the silting up of the Eridanus River in the gulf of the Adriatic. There, he came upon the hot, fetid lake where Phaethon, son of Icarus, fell, and where the black poplars on its banks oozed amber that the natives collected for trade with the Greeks. During his stay on these islands, Daedalus erected two statues, one of tin and one of bronze, in the likeness of himself and of his lost son.

There are recurring themes in all these myths: the death of divine or heroic youths, the mourning of the young, the sun (which was responsible for Icarus' death as well as Phaethon's), and the sea. Many of the Greek and early Roman stories about amber place its origin in the far north, and it is likely that the earliest myths incorporated knowledge of the northern solar cults and the medicinal and magical properties of amber.

Not only was amber connected to the sun, it came to be immortalized in the stars. It is a characteristic of all precious stones in antiquity to have had a planetary or celestial association, and by the third century at least, the Eridanus was thought to have been transformed into a constellation, the eponymic Eridanus, or River. Late Antique sources

recount how Phaethon became the constellation Auriga, the Heliades became the Hyades, and the Ligurian prince became the Swan.[89] In Late Antiquity, Claudian described the river god Eridanus, no doubt in a manner long imagined: "on his dripping forehead gleamed the golden horns that cast their brilliance along the banks...and amber dripped from his hair."[90] Why, as Frederick Ahl asks, is Swan a friend of the Sun's child? The answer to this question explains in part why amber was important in ancient Italy, and why the long-necked birds are represented early and often in the "solar" material. The swan was a cult bird in northern Europe during the height of Celtic power, in the Urnfield and Hallstatt phases of European prehistory. "The evidence strongly suggests that this bird was especially associated with the solar cults which were widespread in Europe, and which can be traced from the Bronze Age, into the Iron Age."[91]

The constellation of Eridanus "wets the clear southern skin in its tortuous course and with starry stream flows beneath Orion's dread sword"—so writes Claudian in his panegyric of A.D. 404. Here, too, amber's place in Greek myths suggests that it was viewed as an ancient material, something belonging to a great age of the distant past. But it also had a practical life outside of myth—by Pliny's time, amber was very common in Rome, and a great number of amber objects were being used, as jewelry, incense, pharmaceuticals, and furnishings for the dead. Nonetheless, amber's mythological significance would have had a powerful effect on the way the material was seen and employed in everyday life.

Of course, as soon as one begins to delve deeper into the relationship between the myths and reality of amber, it becomes difficult to distinguish which is which. The myths about amber's role in the mourning of the dead and the actual funerary use of amber, for instance, both have a direct correlation to the fact that amber can sometimes act as a tomb itself.

The connection of amber, tombs, and funerary customs is brought together in a unique Etruscan amber, the bow of a *fibula*, in the Metropolitan Museum of Art, the so-called Morgan Amber, possibly

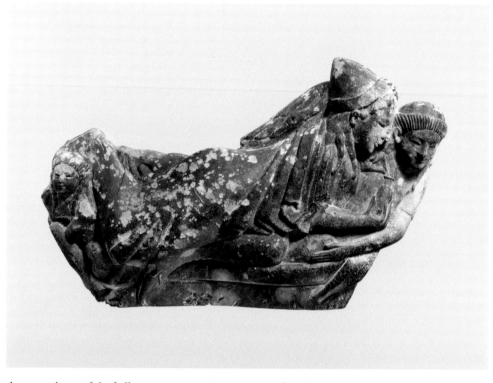

the most beautiful of all surviving pre-Roman carved amber objects (figure 26).[92] The bow is carved into a complex grouping: a draped and shod female wearing a pointed hat holds the base of a small vase in her right hand and touches it with her left. The young, beardless man with flowing hair, long garment, and bare feet, supports himself on his left arm. Nestled between them is a long-necked bird, presumably a swan. At the foot of the couch is an attendant. The amber likely depicts a ceremonial banquet, but is the couple mortal or divine? Are the figures Aphrodite and Adonis (Etruscan: Turan and Atunis) and the bird, the goddess' swan? Or is this an elite couple? If so, is the swan a symbol or part of the event? The iconography of the reclining couple and the ceremonial banquet had spread earlier from the Ancient Near East to Greece and Etruria, and in Archaic Etruscan art significant sculpted and painted depictions are extant. If this were a funerary object and the subjects divine, rich mythological implications are possible. If the sub-

jects were mortal, the pin may have functioned as a "substitution" for the deceased. Jean-René Jannot writes about the Etruscan-depicted dead:

> "Was [a wall painting, an effigy sarcophagus] considered the physical envelope for that which does not die, the *hinthial* [soul, or shade]? None of these monuments were made to be seen…Was the deceased, through his material image, believed to be living in the funerary chamber, which has become a house, or in the trench where offerings of food were set out for him?"[93]

61

FIGURE 26
Bow of a *Fibula* (safety pin)
with Reclining Figures,
Attendant, and Bird,
Etruscan, ca. 500 B.C. Amber,
L: 14 cm (5½ in.). New York,
Metropolitan Museum of
Art, 17.190.2067. Gift of
J. Pierpont Morgan, 1917.
© The Metropolitan Museum
of Art/Art Resource, NY.

Certainly, the inclusions in the amber—life visibly preserved for eternity—would not have been ignored in preparing amber for funerary purposes.

The insects and flora in amber, which Aristotle, and later Pliny and Tacitus,[94] point to as proof of amber's origin as earth-born, as tree resin, are apt metaphors for entombment and for the ultimate functions of the funeral ritual—to honor the deceased with precious gifts and to make permanent the memory of their lives. Three of Martial's epigrams are devoted to this correlation:

> Shut in Phaethon's drop, a bee both hides and shines, so that she seems imprisoned in her own nectar. She has a worthy reward for all her sufferings. One might believe that she herself willed so to die.
>
> As an ant was wandering in Phaethonic shade, a drop of amber enfolded the tiny creature. So that she was despised but lately, while life remained, and now has been made precious by her death.
>
> While a viper crawled along the weeping branches of the Heliads, a drop of amber flowed onto the creature in its path. As it marveled to find itself stuck fast in the viscous fluid, it stiffened, bound of a sudden by congealed ice. Be not proud Cleopatra, of your royal sepulchre, if a viper lies in a nobler tomb.[95]

It is very unlikely that a swift, small snake could be entombed in such a fashion, but it is also only fair to allow Martial a degree of poetic license, given Cleopatra's traditional association with the asp. A more intriguing possibility remains, however: that Martial was describing something he had actually seen or heard about—an early instance of amber forgery.[96]

AMBER AND FORGERY

If amber could be guaranteed to have been acquired from an exotic location such as the distant north, the mythical Eridanus, or the Elektrides islands, or if it embodied one of its more mystical properties—natural luster, powerful magnetism, or a particularly impressive inclusion—it would have had greater worth as a magical or medicinal item, as well as being more valuable as an ornament. Practically speaking, such a piece would have fetched a much higher price than an unprovenanced, or poorer grade amber object. Then, as now, the impetus for forgery or false provenances would have been commensurate with the price. Roger Moorey, addressing the issue of forgery in relation to blue-colored stones in the ancient Near East, writes that "the desire for rare coloured stones was so great that it stimulated the development of artificial gemstones, made first, before about 2000 B.C., of glazed dull stones or of faience and increasingly thereafter of glass."[97]

It is likely that various tree resins (particularly copal, a hard resin of a much younger age than amber) might have been taken for amber—at least at the time of purchase—either through deliberate deception or because of a genuine misunderstanding.

Of course, the fact that some of the materials used to imitate amber also possessed, to some degree, the same qualities for which amber was prized means that they may have been valued in their own right, and it is therefore usually impossible to distinguish cases of successful deceptions from resins that were never intended as impostors. Tutankhamen's tomb, for instance, was found to contain various non-amber resin objects along with genuine amber ornaments.[98] Were they forgeries intended to be seen as amber or another high-value resin, or were these materials equally well valued for their own sake? Was the difference readily apparent?

Evidence of other amber-related forgeries in antiquity can be found in Pliny, who discusses the use of amber itself to approximate transparent gemstones, notably amethyst. Pliny also describes a technique for softening amber (a necessary step in clarifying it, and one preliminary to amalgamating small pieces of amber into a larger one, as is still done

today). Although there is no extant ancient example of such an amber object, it is a compelling explanation for certain larger works referred to in ancient sources, such as the large drinking vessels mentioned by Juvenal and Apuleius,[99] or the statue of Augustus at Olympia described by Pausanias. What we do have as examples of amalgamated amber pieces are segmented amber *fibulae* and a few carvings with added patches of amber, held together with glue or by adhesion with oil and heat. *Fibulae* sections were joined with reeds, sometimes covered in metal foil. Today, two pieces of amber may be united by coating surfaces with linseed oil, heating them, and then pressing them together while hot.

There would probably not have been a need to conceal that such pieces were joined or amalgamated, their craftsmanship being just as impressive as their size. It would also have been generally known that they were composed of pieces rather than one large pure amber, since amalgamation techniques were common in Rome for other media, such as large ivory statues, wood marquetry, or glass. The greatest example of joined amber plaques is the famous Amber Room in the Catherine Palace at Tsarskoje Selo, Russia, now reconstructed. "Compressed" or "mosaic" amber (as it is called today) is often darker and less lustrous than natural amber. Given the immense importance attached to amber's natural sheen, artificial coloring applied to a high-value object might have been deceptive in much the same way as an inclusion forgery like Martial's snake. Pliny was aware that good examples of pieces displaying amber's unique qualities, such as inclusions or brilliance, were valued according to the secret knowledge they seemed to encompass as natural wonders, and he implies as much in his discussion of the artificial coloring of amber.

The exact nature and extent of amber forgery in and before Pliny's time is admittedly something about which we can only speculate, but it was an early part of a continuing interest in making amberlike materials for scientific, manufacturing, and aesthetic (as well as more dubious) ends.[100] In the early modern period, this interest is documented by no less a figure than Leonardo da Vinci, who describes one recipe for making fake amber from egg whites hardened by heating.[101]

FIGURE 27
Seated Divinity Statuette,
modern. Amber, H: 28 cm
(11 in.), W (of base): 13.5 cm
(5³⁄₁₀ in.). Los Angeles,
The J. Paul Getty Museum,
82.AO.51. Gift of Vasek Polak.

In China, the high value placed on amber has resulted in counterfeiting since at least about A.D. 500, the date of Tao Hung Ching's book of *materia medica*. There he warns against false amber and recommends "using the electrostatic ability of amber to attract straw as a means of distinguishing amber from imitations."[102]

More recently, significant modern forgeries of ancient amber objects have come to light. These include an "Assyrian" amber statuette of King Ashurnasirpal in Boston[103] and the *Apollo of Fiumicino* (Paris, private collection) made in the early twentieth century, probably by the same carver responsible for the Getty statuette of a Seated Divinity (figure 27).[104]

Today, amber counterfeits like the *Seated Divinity* and the *Apollo* are made with a mixture of modern materials such as synthetic resin and plastics, as well as compressed amber and other resins. The interest today in amber forgery—in fake jewelry or fake specimens—is such that many modern publications and websites are available to help identify and distinguish amber, copal, and the wide range of manufactured-amber imitations.

THE ANCIENT TRANSPORT OF AMBER

There is evidence for the movement of amber as early as the Paleolithic era. Rough pieces have been found in ancient dwelling caves in Britain and northern Europe at some distance from the amber sources.[105] Early on, the main transport of amber to the Mediterranean was likely a chain of exchange—there was no defined long-distance amber trade until the mid-second millennium B.C., when it was probably acquired in both raw and finished form.[106] It is likely that amber traveled overland to the Mediterranean via the long route between north and south Europe, all along the Oder, the Elbe, the Vistula, the Rhine, the Dniester, and other main European rivers.

It also traveled east. By sea, for a long period it was carried, like tin, through the Gates of Hercules; Phoenicians were likely the main transporters. For amber intended for the markets of the Italian peninsula, the Adriatic appears to have been the main destination.[107] Once at the Adriatic, amber must have been moved by water along the Italian coast, finding its way inland along the river valleys and mountain passes. It was likely traded from further west and welcomed along with the Aegean and eastern Mediterranean goods being transported to the central and western Mediterranean. The existence of raw and worked amber from sites around the Mediterranean and further afield from the Bronze Age onward—on the Iberian peninsula, in Mesopotamia, Anatolia, at Ugarit on the Syrian coast, and in Egypt—attests to its widespread value and transmission. Trade in amber was likely a series of short-range transactions from the sources onward, with a few

outstanding exceptions. We should imagine seekers traveling to the north, to amber's deposits, in order to obtain the precious material and to learn its secrets. The "knowledge" that accompanies a highly prized substance was as important as the thing itself.

There is no literary evidence for direct trade between Italy and the north until the first century A.D. Pliny writes of a Roman knight, commissioned to procure amber for a gladiatorial display presented by Nero, who traversed both the trade route and the coasts, bringing back an extraordinary amount of the precious material, which was used to decorate the arena extravagantly. Like the rare animals that were sometimes displayed at such events, amber nourished the idea of exotica from afar—visible affirmation of Rome's domination of the world.[108]

LITERARY SOURCES ON THE USE OF AMBER

The archaeological record hints at a variety of uses of amber throughout the ages that are sometimes complemented by the surviving literature, though often they are not. Certainly those uses that were by nature magical or tied up with mystery religions are unlikely to have been referred to other than obliquely in any mainstream literature, although they were extensive and widely acknowledged from very early on, through the Classical era, and well into the Middle Ages. In addition, as helpful as the archaeological record is in elucidating the use of amber in mourning and burial contexts, it is less so when it comes to the everyday employment of amber as documented in the literature. Its use among the very wealthy ranged from girls' playthings, to decorative items such as the amber-encrusted goblet that Juvenal mentions in a satire, to sculpture such the imposing one of Augustus that Pausanias describes, to magical and religious purposes—amulets, incense, fumigation, or burnt offerings (which by definition do not leave any physical trace). Martial writes of the pleasant odor amber gives off when it is handled by girls, of "amber nuggets polished by hand," and compares kisses to well-worn amber.[109] In a letter to Marcus Aurelius, Fronto speaks scathingly of those writers [Seneca and Lucan] who "rub up

one and the same thought oftener than girls their perfumed amber."[110] These analogies provide some explanation for the wear on many pre-Roman amber beads; magical use explains it further (figure 28).

Pliny (as usual) has a long list of possible uses: amber is carved into figurines (compare figure 29),[111] fashioned into truffle-cutting knives,[112] made into artificial gems,[113] and in Syria used for spindle whorls. He further describes amber drinking cups, arms, and decorations of the arena (uses which would have been appreciated by men as well as by women), although he prefaces these examples with denunciatory comments at the beginning of Book 37: "The next place among luxuries [after myrrhine and rock crystal], although as yet fancied only by women, is held by amber. All three enjoy the same prestige as precious stones...but not even luxury has yet succeeded in inventing a justification for using amber."

67

Female Head in Profile Pendant, Etruscan, 525–480 B.C. Amber, H: 5.7 cm (2¼ in.), W: 5.6 cm (2⅕ in.), D: 3 cm (1⅕ in.). Los Angeles, The J. Paul Getty Museum, 77.AO.81.4. Gift of Gordon McLendon.

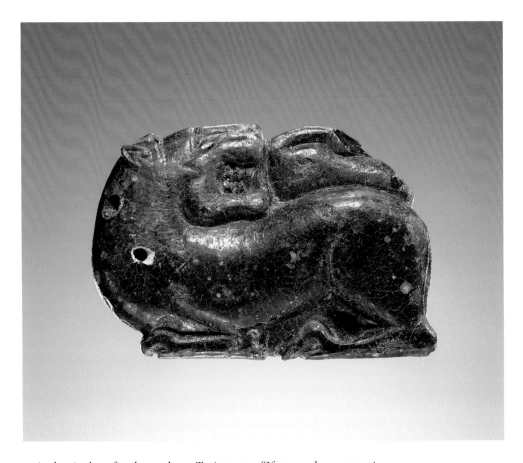

Amber is also often burned—as Tacitus says: "If you make an experiment of burning amber by the application of fire, it kindles, like a torch, emitting a fragrant flame, and in a little time, taking the tenacious nature of pitch or resin."[114] Pliny observes "amber chippings steeped in oil burn brighter and longer than the pith of flax."[115] This suggests that amber may have had a practical use as interior lighting. Pliny also cites evidence that the northern Guiones use amber as fuel instead of wood and refers to what must have been a very common use of amber as incense, suggesting that in India, "amber was, to its inhabitants, found to be more agreeable even than frankincense."[116]

Such burning may seem a rather wasteful use of a precious material, but it was essential for offerings, for communication between the

human and the divine, and even for feeding the gods, as in Egypt.[117] As J. Todd has pointed out, "From the earliest recorded times burnt offerings and specifically incense are considered the most sacred gifts of all. The burning of amber would not have been considered a destructive act, but rather an elevated use of the material."[118]

Amber burned as incense was of great consequence in rituals involving solar deities before and during the Classical era, since both amber and incense were symbolic of the sun in the ancient world.[119] Incense, which would disperse a fragrant smoke when scattered on lighted coals (either in a stationary or movable burner or censer) was a regular element in Babylonian religious ceremonies.[120] The thousands of incense burners found in sanctuaries and graves throughout Greece and Etruria attest to the great importance of burning fragrant gums and spices. One of the oldest Etruscan tombs at Cerveteri, opened in the nineteenth century, was found to include "bits of amber and other oriental gums placed around the corpse." A morsel carried off and later ignited by the excavator, "caused so powerful an odour as to be insupportable."[121]

"Incense 'offerings' were a normal part of sacrificial rituals and the use of incense was often called for in magical rituals."[122] In China, a nineteenth-century traveler records, chippings and amber dust left over from cutting figured pieces were used for varnish or incense. "The burning of the odiferous amber is the highest mark of respect possible to pay a stranger or distinguished guest, and the more they burn the more marked is their expression of esteem."[123]

In ancient medical practice, incense, resins, wood shavings, and other odoriferous materials (usually plants) or aromatics were used as a form of fumigation, whether alone or in compounds. It is also likely that amber incense was used in divination—omens being read in the plumes and short curls of smoke formed by burning amber (figure 30).[124]

Amber incense may have been ground into a powder and mixed with other ingredients such as other aromatics, or nitrates, to keep it burning. In Rome, as Karen Polinger Foster shows, incense was "shaped into cones, balls, discs, pyramids, obelisks, granules, and pellets as it had been in Egypt and the Near East."[125] But the Romans apparently

FIGURE 29
Lion with Bird Pendant, Etruscan, 600–550 B.C. Amber, H: 4.2 cm (1⅗ in.), W: 6 cm (2⅜ in.), D: 1.5 cm (⅗ in.). Los Angeles, The J. Paul Getty Museum, 77.AO.81.2. Gift of Gordon McLendon.

did not follow the Egyptian practice of using figurative incense blocks, in forms such as birds or recumbent calves, which clearly suggests a religious element to the burning of incense.[126] A few pieces of unworked amber found in Etruscan graves might be construed as evidence of amber used for fumigation or as unburnt incense.[127] And it may be that the very same amber objects considered then and now as ornament and amulet (for example, birds or recumbent calves) might also have been valued for their potential as light energy or incense.

AMBER MEDICINE, AMBER AMULETS

Because of its beauty, saturated color, and translucency, amber was seen in antiquity not only as an ornament, but also as a supernatural and curative substance. To be overly concerned with the distinction between the roles of amber (sacral, ornamental, magical, medicinal) is perhaps to miss the more subtle relationships between them. Pliny makes no such mistake: "Even today," he writes, "the peasant women of Transpadane Gaul wear pieces of amber as necklaces, chiefly as adornment, but also because of its medicinal properties. Amber, indeed, is supposed to be a prophylactic against tonsillitis and other affections of the pharynx, for the water near the Alps has properties that harm the human throat in various ways."[128] "Amber is found to have some use in pharmacy," Pliny goes on to say, "although it is not for this reason that women like it. It is of benefit to babies when it is attached to them as an amulet."[129] In this passage, we find one of the two surviving ancient literary references to an amulet of amber, a use (the archaeological evidence tells us) that was pervasive from as early as the mid-second millennium B.C. Caesarius of Arles gives us

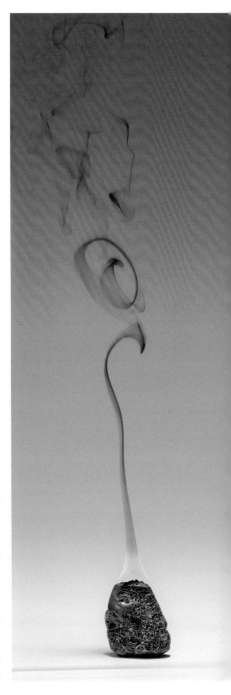

FIGURE 30
Piece of burning Baltic
amber, producing its
distinctive flame color and
characteristic smoke. Length
of amber before burning:
3 cm (1⅛ in.). Private
collection. Photograph
© Lee B. Ewing.

FIGURE 31
Head of Medusa, Roman,
1st–2nd century. Amber,
H: 5.8 cm (2³/₁₀ in.), W: 5.8 cm
(2³/₁₀ in.). Los Angeles,
The J. Paul Getty Museum,
71.AO.355.

the other: he warns his readers against wearing "diabolical" amulets made of certain herbs, or of amber, around the neck.[130]

What did these amulets look like? The ones that Pliny refers to may have been perforated and polished raw lumps; or perhaps they were *bulla*-shaped or crescent-shaped.[131] It is possible that they were made into special shapes, including figural subjects, as had been traditional for amber amulets in the north of Europe and around the Mediterranean (and beyond) for millennia. Might one of Pliny's amulets be similar to the Roman *Head of Medusa* (figure 31) in the Getty collection? Or might they have been like one of numerous surviving small carvings in amber—bird and animal figures, or corn ears and fruit—given as New Year's presents in imperial Rome? Several of these New Year's gifts have inscriptions referring to this, evidence that the magical properties of amber were still significant.[132]

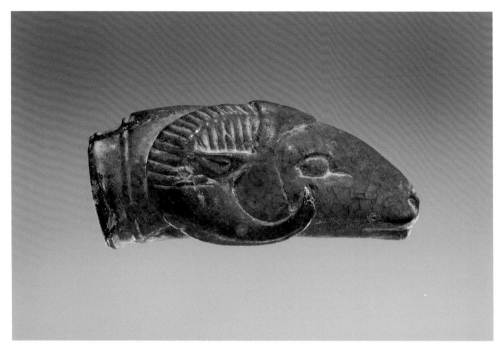

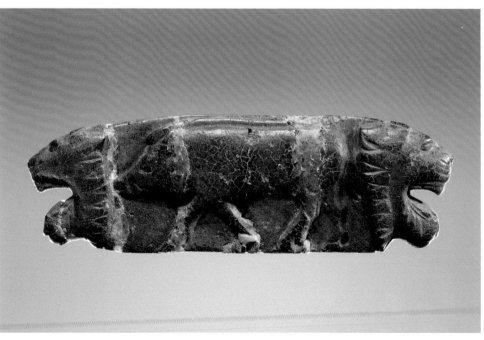

The act of writing on or figuring a material—providing it with a face or a form—gave it new significance and power.[133] Writing on a gemstone or amulet might be done "to create the impression of mysterious power by virtue of the writing itself."[134] Now, in addition to the associations the material itself carries with it, the figured object has become a metonym for a past event, or a desired outcome, or perhaps for the attributes of a deity (figure 32). Such an object derives new significance when it is attached to a person—tied around the neck, perhaps, or fastened to the arm or a girdle. Unsurprisingly, the Greek terms for amulets, *periammata* and *periapta,* come from a verb that means "to tie on," and an amulet worn by a human can be defined, quite simply, as a powerful object attached to a person.[135] Ancient amulets range widely in type, from natural objects,[136] to simple carved pendants, to figured objects, as well as *lamellae*, objects inscribed with magical symbols or incantations to prevent evil. The material from which the amulet was made was critical. T. G. H. James suggests: "Although certain materials, semiprecious stones in particular, were invested with magical properties in ancient Egypt, it seems that these properties were usually only activated when the stone in question was used for the manufacture of amuletic figures of specific kinds."[137]

Almost any jewelry object could have had some sort of an apotropaic function—and, as Geraldine Pinch remarks in her book on Egyptian magic, it is hardly an exaggeration to say that most Egyptian jewelry has amuletic value. How conscious the wearers were of the symbolism of their ornaments is a more difficult question.[138]

The same is evidently true for amber objects of adornment. In life, amulets were worn as charms to bring good luck, health, protection, or love, to avert danger, or to cure disease. Those amulets that were figured or inscribed would often have had a sympathetic function;[139] a figure of a boar, such as the Getty plaque *Addorsed Lions' Heads with Boar in Relief* (figure 33), might have brought luck in a hunt, safeguarded the wearer from the boar he was hunting, or may even have channeled the powers of Herakles or Meleager. Occasions such as a hunt, a dangerous journey, or the birth of a child would have

FIGURE 32
Ram's Head Pendant, Italic, 500–400 B.C. Amber, L: 3.6 cm (1⅖ in.), W: 1.9 cm (¾ in.), D: 1.5 cm (⅗ in.). Los Angeles, The J. Paul Getty Museum, 77.AO.81.15. Gift of Gordon McLendon.

FIGURE 33
Addorsed Lions' Heads with Boar in Relief Plaque, Etruscan, 500–480 B.C. Amber, H: 3.6 cm (1⅖ in.), W: 8.2 cm (3⅕ in.), D: 1.2 cm (1⅕ in.). Los Angeles, The J. Paul Getty Museum, 77.AO.83. Gift of Gordon McLendon.

warranted temporary amulets for specific situations.[140] More permanent amulets, in the form of jewelry, could have provided protection during childhood, throughout an individual's life, and during the fraught voyage to the afterworld, the dangerous realm of spirits and demons. Indeed, amber and amber amulets were important elements in the ritual of mourning, as permanent tears and as grave gifts.[141] For the ancients familiar with the Phaethon or Meleager myths, the tears may have called up the weeping of the youths' sisters, the Heliades or the Meleagrides. In inhumation burials, the body might be dressed with amber-ornamented garments and amber jewelry; in cremations, amber jewelry might be placed atop the ashes. In rare cases, amber objects were set outside the containers within the grave.

The impact of the Aegean, the Near East, and Egypt (where women and children wore the majority of amulets) on native Italian customs during the first millennium B.C., a period of contact and acculturation, is evinced by the subjects of the amulets. New images, spells, and amulets, new deities and aspects of deities, replaced, perfected, or married with the old. Although only a portion of the extant figured ambers can be associated with religious cults, the use of amulets was certainly bound up with secret knowledge of sources of power—the province of skilled practitioners such as magicians, priests, "wise women," healers, or midwives.[142] Practitioners of magic might exert an influence on all levels of society. Theophrastus maintains that Pericles, on his sickbed, was induced by the women of his household to wear an amulet—entirely against his better judgment. The story, whether apocryphal or not, is further evidence for a widespread use of amulets among the elite, as well as the lower classes.[143] It is also interesting for its indications about the role of women in promoting such use.[144]

Amulets were especially valuable to women for controlling or increasing fertility, protecting the unborn, helping to ensure a safe childbirth, and safeguarding their children. Protective gynecological amulets must have been among the earliest of all amulets. The practices in Italy or in the Greek world were age-old, the lore passing

from generation to generation, no doubt affected by contact with new populations, practitioners, and magical practices.

One of the seventh-century plain pendants in the Getty collection is inscribed with two images, a fish on one side, and on the other, something resembling the Egyptian symbol of a pool with lotus flowers or a clump of papyrus, both water subjects (figure 34). This piece is one of forty-three beads from the same parure, its original find spot now unknown. Who scratched the signs? How were they understood? Was even the presence of Egyptian, or Egyptianlike, writing enough to make the amber more efficacious?

The serious dangers of disease in young children and the considerable risks for women in childbirth and early motherhood gave rise to a

FIGURE 34
Pendant inscribed with two Egyptianizing hieroglyphs, 7th century B.C. Amber, H: 3.8 cm (1½ in.), W: 2.2 cm (⅞ in.), D: 0.8 cm (³⁄₁₀ in.). Los Angeles, The J. Paul Getty Museum, 82.AO.161.285.

belief that the dead were jealous of new life, and the need for magical protection of women and children was a compelling one.[145] Many ancient ambers are carved into Dionysiac subjects. The god's own infancy and childhood were significant in myth, and he was a revered father, no doubt essential in his role as protector of the young.

For a pregnant woman, moreover, amber's property of encapsulating living things may have made it an especially powerful *similia similibus* amulet, a "pregnant stone."[146] Resin also heals damage and wounds in trees; could it extend such properties to people wearing it?

The *bulla*, a lens- or bubblelike container, is perhaps the best known of all ancient amulet shapes. Known in Rome as *Etruscum aurum*, it combined two magical functions: it enclosed amuletic substances, and it symbolized the sun, in material, in form, and in its powers.[147]

The shape derives from the age-old disk amulets of the sun. The *bulla* was given to high-born boys: the ancient sources relate that the king Tarquinius Priscus was the first to present his son with a gold amulet after he had killed an enemy in battle, and from that time on the amulet was worn by the sons of cavalrymen. Ancient sculpture shows that Etruscan boys wore the *bulla,* and Roman writers recount that it was worn by magistrates, triumphant generals, and even domestic animals. *Bullae* might be made not just of gold but of other bright metals, such as bronze, as is evidenced by examples found in Latin and Etruscan graves dating as early as the eighth century B.C.

In fourth-century pre-Roman art, the single *bulla* as well as strings of *bullae,* not only lens-shaped but also pouch-shaped pendants, are worn by elite personages, some of them recognizable as divinities and heroes. Dionysos wears a single *bulla* on the Praenestine "Cista Napoleon" in the Louvre.[148] On an Etruscan red-figure crater in Florence, an Argo-

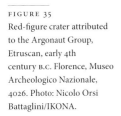

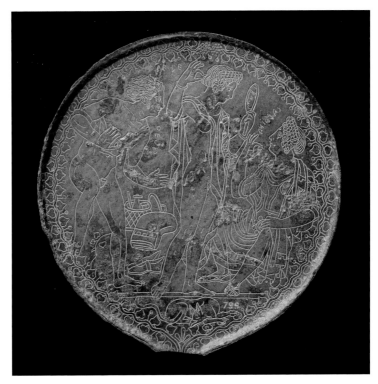

naut wears strings of *bullae* on his arms, while a companion ties on yet another (figure 35).[149] Might his *bullae* be made of amber? What better material, considering its lightness, amber's safeguarding and buoyant properties, and the Argonauts' destination to the northern lands?

On a sarcophagus from the Tomb of the Triclinium at Tarquinia, a reclining woman wearing a necklace of *bullae*, holding a *thyrsus* and *kantharos*, and keeping a fawn by her side, is clearly a devotee, or maybe a priestess of Dionysos/Pacha/Fufluns. On Etruscan mirrors Aplu, Fufluns, Tinia, Epiur and Maris, young Hercle, Thetis and Alcumene, Athena and Turan wear *bullae*.[150] Votive images of women, girls, and boys, and effigies of deceased men, women, and babies are often shown with a *bulla* or *bullae*.[151] A mid-fourth-century mirror in New York (figure 36) shows Peleus wearing an armlet with *bullae* on her left arm and Calaina (Galene), a nereid, holding a circlet with *bullae* in her left hand.[152]

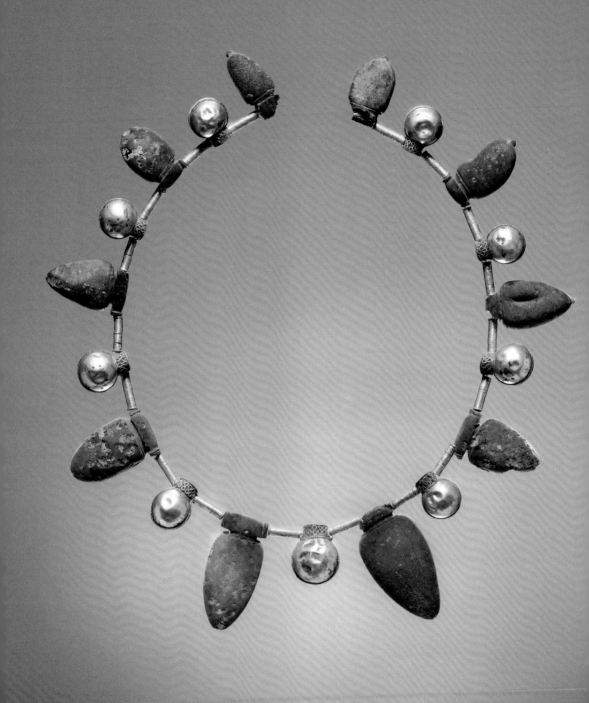

As early as the eighth century, the *bulla* was imitated in amber for pendants on necklaces, but it is important to note that documented finds of amber *bullae* come almost exclusively from elite female burials.[153] Strings of amber *bullae* excavated in Latium and the Basilicata date to the early seventh century. *Bullae* of amber were special translations of the form: they were sun-shaped and sun-colored, shining like the sun, and instead of containing amuletic substances inside a metal envelope, the material itself was a curative (*remedia*) that could enclose inclusions (figure 37).

If amber was fiery and glowing, the most prized characteristics, then this alone might have ensured it a special protective and sanctifying role.[154] Amber could also symbolize constancy. Amber necklaces were gifts for brides, mortal and immortal, as the ancient sources tell us.

Another sympathetic function of amber amulets might have been their ability to focus the powers of a particular deity and astrological force. Amber's magnetic properties gave it a special role in attraction (and displacement), and because of its already potent associations with the sun, amber may have been seen to be able to attract and fix the sun's influence.[155] Ancient beliefs in the potency of stones in drawing down the power of the planets and stars, and especially the rays of the sun, were widespread and are described first in Egyptian texts and later in Hermetic writings on talismans. We might extrapolate from such sources how amber might have worked in this regard. One Hermetic papyrus describes how "the magician draws down to earth the spiritual powers of the star, planets, and fixes them in talismans prepared of the proper substances and engraved with or shaped into the proper symbolic forms."[156] In early modern Europe, amber, gold, and rubies—all solar materials—were believed, like the sun, to have the property of generating the vital spirit of the microcosmos.

It is not difficult to see how a shiny amber amulet would have been thought to contain some of the sun's light within itself or to allow light to pass through it in some active sense. In Greece and Italy, accompanying such amulets were songs, healing words, spoken prayers, and incantations. Roy Kotansky traces the use of written incantations and

FIGURE 37

Necklace, Italic, 550–400 B.C. Amber and gold, L (approx): 39.5 cm (15⁹⁄₁₆ in.). Los Angeles, The J. Paul Getty Museum, 77.AO.77.5. Gift of Gordon McLendon.

symbols with amulets back to the rituals of Egypt and the Near East and notes that these "may have been transmitted to Ancient Greece and Italy by traditional folk means, traders, or itinerant medicine men or women."[157]

There is a relative paucity of information in Greek and Latin literature about amulets and their use, as noted above, and much of the archaeological evidence awaits study. However, what does exist is enlightening, as recent scholarship shows. Some well-known examples indicate how pervasive was the use of "tied-on" substances: Pericles, sick with the plague, was prodded into wearing an amulet around his neck. Socrates in Plato's *Republic* list amulets and incantations as among the techniques used to heal the sick.[158] More is known about Egyptian and Near Eastern amulets, both from written sources and from archaeological evidence. Such information may be useful in coming to conclusions about the early Greek and Italian use of amulets, but despite the similarities, it would be a mistake to assume that all such usage will have had Oriental prototypes. Much less is documented about northern European practice, and yet many of the subjects of the figured amber pendants found in Italy (figure 38) have Baltic precedents that are thousands of years older: standing human figures, faces and detached heads, bears, or hoofed animals.[159]

From the point of view of amber amulet usage in Italy, seven large ambers, four of which are figured—two female heads and two satyrs—found in Tomb 48 at Ripacandida are of great interest.[160] Angelo Bottini has suggested that the objects were not part of a necklace but may have been put inside a pouch or strung together to form a chaplet or a sort of rosary.[161] Largish bronze rings with interspersed protrusions, too large for a bracelet, have been found in graves throughout Archaic Italy. A chaplet with beads held by the figure of Calaina on a fourth-century Etruscan mirror (figure 36) may point to a connection with an ancient Near Eastern female divinity, for in Assyrian art, a chaplet, or circlet, of beads is an attribute of a goddess.[162] Amuletic pouches, containing all sorts of potent materials and objects, are still popular throughout Italy. Hundreds of such protective bags, *cacchottini*, many

FIGURE 38
Female Holding a Child (*Kourotrophos*), Etruscan, 600-550 B.C. Amber, H: 13 cm (5⅛ in.), W: 4.5 cm (1¾ in.), D: 1.8 cm (⁷⁄₁₀ in.). Los Angeles, The J. Paul Getty Museum, 77.AO.84. Gift of Gordon McLendon.

80

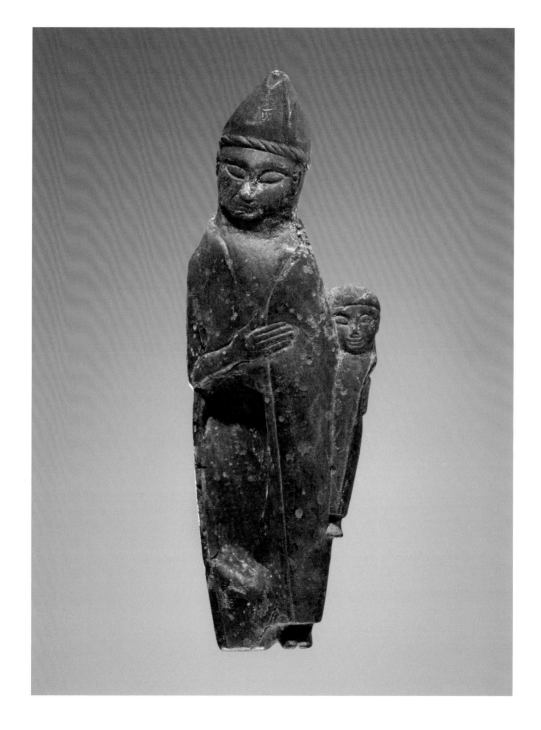

of them of great age, were collected and studied by Giuseppe Bellucci at the end of the nineteenth century.[163]

Using terms such as *necklace, armlet, collar, pectoral,* or *girdle* for worked amber objects minimizes their ties to older amuletic traditions. There is a long history of such strings of amulets (some are seals) throughout Europe, in the Mediterranean littoral, and in the Near East. Such groupings are documented as early as the Early Dynastic period (third millennium) at Ur.[164] Mesopotamian texts specifically refer to figured amulets in the context of protection and healing, either as amulets that were to be carried and worn by the living or placed on various parts of the deceased's body. Strings of amulets are documented in the ancient Near East as hanging in the house. In Greek, Cypriot, and Etruscan art, babies and children (and some Greek young women) are depicted wearing amulets tied onto a long cord worn diagonally across the body. This tradition may well be the ancestor of the Roman *crepundia*. As Demetrius Waarsenburg argues, the *crepundia* (charms strung together and used as rattles for children) can be connected to these assemblages of amulets, implying that they originally had a more profound significance.[165]

Although nearly all of the figured amber pendants excavated in Italy have been found in funerary contexts, many of them would have had "lives" and an owner or owners (not necessarily the deceased) before they became part of the ritual of mourning. Interments could contain both old and new pieces. Some may have been heirlooms; some gifts, already venerable and powerful, made so by provenance, status, or accrued potency.

Some beads and pendants show signs of use—of handling, of pulling on the suspension perforations, of rubbing. Was the rubbing done to enliven the electromagnetic properties of the amber? To release its fragrance? For the tactile sensation? To activate amber's divine associations? For medicinal purposes? To enact the magic of the amulet's imagery?

The blurred features of some figured ambers must be due to handling in the course of amuletic use. Several examples from controlled excava-

tions seem to confirm this. A female head from a grave at Latronico retains sharp groovings in the hair and crisp delineations in the diadem, but has smoothed facial features (the tiny chips are likely from modern times). It has a standard perforation through the top of the pendant but also a secondary perforation through the temple area, front to back, which has been elongated by gravity and pull, very like the holes on heirloom Tibetan or African amber beads. The Herakles and satyr heads from a woman's grave, Tomb 106 at Braida di Vaglio, which may be at least a generation older than the burial, are salient examples of non-uniform use wear. The face of the Herakles pendant is especially worn.[166] Some of the figured ambers from another of the Braida di Vaglio tombs, Tomb 102, that of a little girl (figure 6), are clearly worn on the prominent surfaces of the face: the features of one of the frontal female faces is nearly worn off, and three of the rams' heads as well as the pendant in the form of a dormant feline evidence continued handling. This is in contrast to the comparatively fresh surface of other ambers from the tomb, including the recumbent sphinx (which may be at least a generation older than the burial).

A woman's Tomb 48 at Melfi-Pisciolo included at least five figured pendants, but only one female head in profile shows considerable surface wear. It contrasts with the male subject, a crisply detailed winged nude youth in a Phrygian hat with a shield at his side and sword in his hand.[167] A large pendant of Eos carrying off a youth, perhaps Kephalos, from a burial of circa 350 B.C. at Tricarico-Serra del Cedro, is the extreme example of face-rubbing: the youth's face is nearly lost.[168] The female heads from a documented find at Valle Pega (Spina), and the rams' heads from excavated tombs at Bologna show well the contrast between the better-preserved tops of heads and the more abraded faces.[169] A number of the Getty female and rams' heads illustrate similar patterns of wear. Many other carved amber objects from burials throughout Italy (and Serbia) bear signs of wear: pulling troughs at the suspension hole, as in a head of a satyr from Palestrina (figure 39), handled or rubbed surfaces, and repairs, such as the drilling of replacement perforations, or securing broken pieces in mounts.[170]

The sometimes disfiguring large drilled holes in the faces (figures 39, 40, 54 A & B) deserve special comment. Why and when were they bored? Raw amber is sometimes found with large round holes in the center of a piece, the result of the resin forming around a branch or twig (now disintegrated). If a piece of amber were purposely perforated before it was made into an object, the act might have occurred anywhere between the Baltic and Italy, and at any time, for it is likely that amber moved south in both worked and unworked form from earliest times. On a practical level, the holes may have been drilled into the amber to better protect it when it was suspended from a pin; or, once the piece was cored, it would have been suitable for wearing on a pin. The smoothed prominent surfaces of the Getty pendant depicting a *Winged Female Head in Profile* (figure 40), the multiple through-bores, the abrasion troughs in the suspension perforations at the top, and the central hole all indicate that this pendant must have been used over a period of time before it was finally interred in a grave.[171] How, and by whom, amber pendants were used during life is a subject for speculation. Pliny's account is one useful source of information, and the few surviving Archaic and Classical illustrations of people (and divinities) wearing figured elements and amulets around their necks and limbs are valuable evidence for figured pendant usage outside of the grave context.

Paintings or sculptures of figures wearing a string with a single amulet or a group of them (as opposed to necklaces designed with repeating elements) are uncommon in Archaic and Classical art from Italy, but the depictions that do survive depict *bullae*-wearing men,

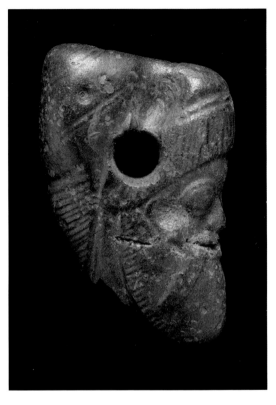

FIGURE 39
Head of a Satyr, Etruscan or Italic, early 5th century B.C. Amber, legacy dimension: 7.5 × 4.7 cm (2¹⁵⁄₁₆ × 1⅞ in.). Museum of Fine Arts, Boston. Gift of Miss C. Wissmann, 02.252. Photograph © 2011 Museum of Fine Arts, Boston.

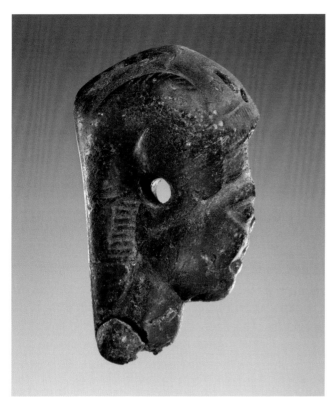

women, and children, horses, and even ravens. On human figures of
both sexes, they are worn around the neck and on the upper arms. The
single ornaments include gorgon masks and the heads of animals, such
as fawn, lion, and ram. A number of terra-cottas of seated goddesses
from Greek sanctuaries in Magna Graecia, for example, wear strings
of figured elements, among them bulls' heads.[172] On Greek vases, on
Cypriot terra-cotta sculptures of temple boys, and on Laconian bronze
images of partly clothed young women are seen cross-torso carriers
bearing various kinds of amulets: crescents, boar tusks, circlets, and
other shapes. Women wearing a single lotus blossom pendant are rep-
resented in terra-cottas, bronzes, and plastic vases of the late sixth and
fifth centuries. Pomegranates and simple flowers are also not unusual.

All amulet wearers depicted on Etruscan fourth-century mirrors
are elite subjects and most are identified as divinities and heroes. Two

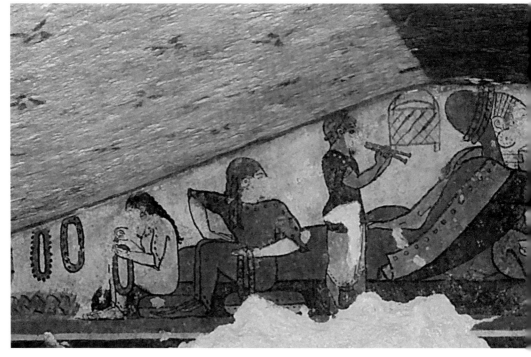

examples are important for amber pendants, especially because of the material's association with Apollo/Aplu and Dionysos/Fufluns. Aplu on many Etruscan fourth-century mirrors wears pendants around his neck or on his upper arm. On an Etruscan mid-fourth-century bronze mirror the infant Fufluns/Dionysos is already adorned with a ribbon of amulets during his birth from Tinia's thigh. Fufluns as a youth, now with a necklace of amulets but otherwise unadorned, is kissed by his mother Semele on another.[173]

Key illustrations of animal pendants in use are painted in the Tarquinian Tomb of Hunting and Fishing (circa 510).[174] On the back wall of the main chamber, the male banqueter (figure 41) wears a necklace of three (amber?) rams' heads almost identical to the Getty amber rams' heads (figures 32, 42). In the first room of the tomb (figure 43), simple carriers with ram and lion's head pendants, similar to those at the Getty (figure 44), hang from branches. This room of the tomb may depict the grove of Apollo, or alternatively, a Dionysian setting.

FIGURE 41
Reclining Couple with an Attendant, back wall of the Tomb of Hunting and Fishing, Tarquinia, Etruscan, ca. 510 B.C. Fresco. Soprintendenza per i Beni Archeologici Etruria Meridionale-Roma/IKONA.

FIGURE 42
Ram's Head Pendant, Etruscan, 525–480 B.C. Amber, L: 3.6 cm (1⅖ in.), W: 2 cm (⅘ in.), D: 1.8 cm (⁷⁄₁₀ in.). Los Angeles, The J. Paul Getty Museum, 76.AO.82. Gift of Gordon McLendon.

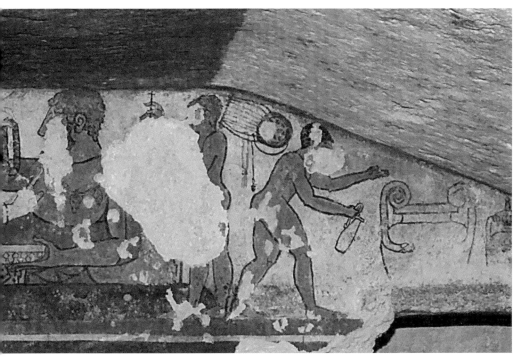

ARCHAEOLOGICAL EVIDENCE FOR THE USE OF FIGURED AMBER: THREE PERIODS OF ABUNDANCE

The Bronze Age

Archaeological evidence attests to a widespread use of amber in the ancient Mediterranean and Near East by men, women, and children, primarily among the elite. As well as its use for amulets and adornment, it was employed to embellish arms and musical instruments, to create spindles, buttons, and pins, and to decorate boxes and furniture. Carved amber and amber-embellished objects were offered to deities and buried in sanctuary foundation deposits. In the Greek-speaking world and in Italy, these deities were almost exclusively female ones, especially those associated with childbirth. Amber was also significant in funerary contexts. Large amounts of it were buried in the Shaft Graves at Mycenae. Four of the graves in Circle A, which included both females and males, contained large numbers of beads: the most prolific was Grave IV, with nearly 1,300. The beads "may have been imported ready-made, since [they] are different from the mass of Aegean ones."[175] The head and chest of the woman buried in Grave Omicron of Circle B was covered with various precious materials, including over a hundred amber beads and spacers.[176]

The resources required to obtain so much amber would have been enormous. At this stage, certainly, amber was a material for the social elite, although as time went on, it would become more widely used. As Helen Hughes-Brock observed:

> The large necklaces and spacer plates were only for the very few and very rich, and hardly found their way beyond the great centers of the northeastern and southwestern Peloponnese. However, generation by generation amber spread over the Mycenaean world and to Crete and down the social scale.[177]

The Late Mycenaean amber is found in tombs of every type, and very occasionally in shrines—although no solid evidence connects it to any particular group of people, deity, or cult. In the ancient Near East, Mesopotamia, the eastern Mediterranean, and Egypt, amber is a rare

FIGURE 43
Figured amulet necklaces in the antechamber of the Tomb of Hunting and Fishing, Tarquinia, Etruscan, ca. 510 B.C. Details from nineteenth-century watercolor paintings by G. Mariani.

FIGURE 44
Lion's Head Pendant, Etruscan, 550–500 B.C. Amber, H: 2.8 cm (1 1/10 in.), W: 2.2 cm (9/10 in.), D: 3.8 cm (1 1/2 in.). Los Angeles, The J. Paul Getty Museum, 76.AO.80. Gift of Gordon McLendon.

substance during the Bronze Age. A recently discovered small (Baltic amber) vessel in the form of a lion's head was one of the exceptional objects placed in the main chamber of the Royal Tomb at late Bronze Age Qatna, at Tell Mishrifeh, Syria (Damascus, National Museum MSH02G-i0759). It, like the other exotic, high prestige objects found on the remains of a multi-burial bier, may have served a ritual purpose. It is the most significant figured amber to have come from an excavation in the region. Was it carved in the Syro-Levantine region, at Qatna even, or might it have been an exchange object or diplomatic gift?[178]

Amber is attested with a high degree of probability in the New Kingdom, from the period of the 18th Dynasty (1550–1295 B.C.) onward, but only in exceptional circumstances and always in conjunction with other precious materials such as rock crystal, gold, lapis lazuli, or faience. Sinclair Hood has argued that a number of the "resin" objects from the tomb of Tutankhamen, including two heart(?) scarabs and the necklace, which he identifies as from the area of the Tumulus Culture of central/northern Europe, are actually amber.[179] The Tutankhamen amber would be one of the very early instances of funerary amber in Egypt, and an extremely early instance of an amber scarab, a form that would become a popular subject in Orientalizing Italy (eighth–seventh century), especially in Etruria, given the scarab's importance as a sun symbol, and its concurrent connection to rebirth.[180]

The importance of amber in Bronze Age northern and central Europe is demonstrated by major finds and significant objects, pointing to several regional centers of manufacture with local characteristics, as Aleksandar Palavestra and Vera Krstić summarize.[181]

In Italy, the Middle Bronze Age finds of amber in the Basilicata and Late Bronze Age finds at Frattesina, in the valley of the Po, are symptomatic of an active trade in both raw and finished products. The amber finds from Italy are early evidence of a long tradition of amber consumption among women of a high social rank on the peninsula.[182]

Early Iron Age and the Orientalizing Period

After about 1200 B.C., amber was much scarcer throughout the Mediterranean until about the mid-eighth century, when it begins to reemerge appreciably in archaeological contexts. For the most part, it is at the end of the eighth and especially during the seventh century when amber was most popular in Greece and peninsular Italy. This is not to leave out a few extraordinary tenth-to-early-eighth-century exceptions, notably at some sites in Italy, in Latium, at Castel di Decima, and most recently in the Roman forum; and in the Basilicata, the area between the Agri and the Sinni, where, in the graves of elite women, remarkable amber parures were discovered. This is the case with a girdle with interspersed bird-shaped beads from the Enotrian Tomb 83 at Latronico.[183] On the whole, amber-embellished objects are buried in both male and female graves, but figured amber is almost exclusively found in those of women and children.[184]

Carved *figured* ambers of eighth-to-seventh-century date are characteristically small (on average, roughly fingertip sized), suggesting that these works, mainly pendants, were carved from small pieces. None are composites, that is, works made from almost imperceptibly joined pieces, as is characteristic of contemporary *fibulae* from Etruria, Campania, and the mid-Adriatic. Among the earliest figured finds are those from the eighth-century necropolis at Veio Quattro Fontanili. They include a standing ithyphallic male, monkeys,[185] a horse, a duck, and a human lower leg and foot, as well as both scarabs and scaraboids, some of which have intaglio horses engraved on the flat sides.[186] All of these are amuletic subjects of great antiquity, and truly Orientalizing.[187] A cinerary urn buried in the First Circle of the Interrupted Stones at Vetulonia (of circa 730–720 B.C.) contained a number of high-status objects, including an amber scarab, thus indicating an object interred after cremation.[188] The scarab may well have been an import, like the accompanying glass beads and bronze Phoenician bowl, although the urn also contained locally produced objects. A number of female graves in and around Magna Graecia each contained but one small waterbird, which may be related to the Egyptian duck amulet, a symbol of regeneration;

it may also be related to the duck symbol of northern Europe. Since the Bronze Age, the duck, a multivalent symbol both guardian and apotropaic, was believed to connect the chthonic and other worlds.[189]

In Greece, worked amber was buried in foundation and votive deposits as well as, more rarely, in graves. A pair of Geometric-date tombs (of priestesses? princesses?) at Eleusis offer critical evidence of the amber in the burial of women of the highest rank.[190] The rich tombs include sumptuous grave gifts, among them necklaces of gold, amber, and faience, and amber inlaid ivory furnishings. The presence of glowing *elektron* bears witness to the lavish and exceptional occasion of the entire funeral process.

Both figured and nonfigured ambers have been excavated at sanctuaries dedicated to a limited number of divinities, mainly female. These include objects from the sanctuaries of Artemis (Ephesus), Artemis Orthia (Sparta), Hera Limeia (Perachora), and Apollo Daphnephoros (Etretria). Intaglios were found at Perachora, and two animals at Aetos (Ithaca). The earliest date to the decades around 700 and represent birds at rest and couchant animals, and, like the contemporary Italian objects, are generally quite small. At Ephesos, the foundation deposit was buried circa 700 near the cellar of the temple of Artemis. Anton Bammer has suggested that the ambers (and accompanying ivory objects) are the remains of a pectoral worn by an early statue of the goddess.[191] Other figured Greek works of this period are the by-now-traditional subjects for figured amber: crouching monkeys, recumbent lions, human heads, birds, ducks, and other species.[192]

The seventh-century ambers from Italy are almost exclusively mortuary and more extensive in number, type, and size than the contemporary Greek examples. As is characteristic of all art from the Orientalizing period, they take on a character different from the eighth-century material, although birds, especially ducks, retain their popular status, as they do in the other figurative arts in Italy. At some sites, figured amber is found in combination with faience amulets of Egyptian fertility and protective subjects.[193] The primary seventh-century finds have come from Etruria, Campania, and Latium; Etruria

Padana and elsewhere in the mid-Adriatic; as well as from the Basili-cata. Recent discoveries at various sites in South Italy and at the Adri-atic site of Verucchio (near Rimini) have greatly modified the picture of amber importation and use. One of the rare figured subjects from the extraordinary amber-rich graves at Verucchio is a *fibula* decoration of addorsed ducks.[194]

Figured ambers excavated at south Etruscan sites include the ubiq-uitous monkeys and a number of standing "nude" females, their arms in various poses associated with fertility.[195] An exceptional example, dating to the first half of the seventh century, is the elaborate grouping of amber pendants and beads (a collar?) found on top of the cremation layer in a tomb at Vetulonia.[196] Little else accompanied the strings of amber: the figured pendants include fish,[197] a scaraboid, seven mon-keys, and eleven standing female figures dressed only in collars and armlets, with legs apart, the vulva exposed, and hands placed on the lower abdomen. The most important pendant represents an enthroned female giving birth, the head of the infant appearing from between her legs.[198] This tiny amber is the strongest evidence to date for a direct link between amber and childbirth.

Many other types of figured amber from the second half of the seventh century correspond to standard Egyptian amuletic iconography. Among the most popular are the dwarf deities such as Bes and Pataikos-Ptah—common Egyptian protective genies.[199] Bes was known to protect sleep-ers and women in childbirth, as well as being a safeguard for the young mother and her children. Both of these figures have solar associations; the Pataikos-Ptah figure, part adult and part infant, was symbolic of the infant sun. Almost without exception, the images of early amber carv-ings were reiterations of Egyptian-sourced solar and rebirth symbols.

The main focus in this book is amber in the form of figural subjects, but the many beads and pendants of this period in botanic or shell forms are also important, since they, too, served a similar role via a metonymic process. Amber cowrie pendants, common in Italy from the seventh to the fifth century B.C., were potent subjects of fertility and childbirth, since the mature cowrie shell was thought to resemble the

vulva. The extraordinary Getty *Cowrie Shell / Hare* pendant (figure 45 A & B), for instance, combines the two subjects of fertility and regeneration. Scarab-cowrie combinations, such as that represented by a ninth-century amber from Tursi (Basilicata), do the same. In Egypt, both real cowries and imitations in gold and other materials were strung together to make girdles and worn in the pelvic region.[200]

The most important surviving ensemble of the seventh century from Italy is that of a high-ranking woman buried at Latin Satricum (Tomb VI).[201] The grave, dated circa 650/40 B.C., contained a flint (actually a Neolithic obsidian scraper),[202] and more than five hundred amber objects—*fibulae*, spindles, nonfigured beads and pendants, as well as numerous figured objects. The medley of stylistic and iconographic connections of the objects is typical of the period and place, but the burial is without parallel—it is the largest single burial with amber from ancient Italy. The figured pieces include nude females and males (some of them doubled and addorsed), fantastic creatures,[203] and fish, and some of the pendants were carved from large amber blanks. Some of the pendants are unique, others variants or copies of Egyptian subjects: fish, Bes, and Pataikos-Ptah. The unworked pieces of amber, here and in other tombs, may also have served as fumigants, unburnt incense, or apotropaics.[204] This grave's goods and the many contemporary large amber *fibulae* of the mid-Adriatic of these decades speak to new sources (geographic or cultural) or to new access to big pieces of jewelry-grade amber.

The Archaic and After

The most important reference to amber from around the year 600 B.C. may be only apocryphal. It concerns the early Greek philosopher Thales of Miletos, the first to recognize amber's magnetism, which he argued was proof of a soul or life, even in inanimate objects. Did he observe this property at home, when watching women spinning Miletos' famous wool with an amber spindle and distaff?

After about 600 B.C., the record shows a change in amber use. Individual pieces and long strings of worked amber become much rarer

FIGURE 45 A & B
Cowrie Shell/Hare
Pendant, Italic or Etruscan,
600–500 B.C. Amber,
H: 3.7 cm (1½ in.), W: 2.6 cm
(1 in.), D: 1.4 cm (½ in.).
Los Angeles, The J. Paul Getty
Museum, 79.AO.75.28. Gift
of Stanley Silverman.

throughout the Mediterranean, perhaps owing to relative scarcity or to fluctuations in trade or even its interruption (by the Celts?). Thus, amber finds from the next decades take on a particular importance. Most are very small pieces used for inlay, in multimedia *fibulae*, in small ivory and bone boxes, or in furnishings. Three composite ivory or bone and amber figured objects dating to the first half of the sixth century are of considerable iconographic importance: a pair of plaques from Tomb 83 at Belmonte Piceno belonging to an elite woman;[205] and a pair from a late Hallstattian Celtic tomb of an elite woman at Asperg, Germany. The two Picene plaques each represent a winged female figure, flanked by two smaller female figures. The winged female is represented in the schema of *Potnia Theron* (Mistress of the Animals) or perhaps another (now unknown) divinity of protection and fertility. The carving is on all sides; the faces (now lost) were inlays of amber. Giulia Rocco attributes the reliefs to Picenum, noting the Greco-Orientalizing character of the figures and their relationship to portrayals of Artemis in the Laconian world. The Halstattian furniture plaques with amber-faced sphinxes are generally believed to be Laconian.[206]

The figured ambers of the sixth-to-fourth century range in size from the tiny (20 mm) to the very large (250 mm) and are formed into a range of subjects, some traditional and some new to the material. They are mainly pendants and *fibulae* bow decorations. Not only is there a wide distribution of finds on the peninsula, but many of the individual pieces are of exceptional size. This is the third great flourishing of archaeologically evidenced amber importation in the Mediterranean-rim area before the time of the Flavian emperors.

Most of the large sixth-to-fourth-century figured works demonstrate a new respect for the original shape of the raw material in its naturally occurring forms—rods, drops, or sheets—with the figural subjects accommodated to the form of the ancient resin. The Italian figured ambers of the eighth and seventh centuries continue ancient traditions, but new kinds of amuletic figuration develop during the sixth century B.C., in response to changing local and contemporary magical, medicinal, and sacral needs. The multifarious seventh-century fertility

FIGURE 46
Foreparts of a Recumbent Boar Pendant, Etruscan, 525–480 B.C. Amber, L: 5 cm (1⁹⁄₁₀ in.), D: 1.3 cm (½ in.), H: 2.4 cm (⁹⁄₁₀ in.). Los Angeles, The J. Paul Getty Museum, 76.AO.84. Gift of Gordon McLendon.

and hunting divinities begin to be replaced by Olympian subjects and hitherto unknown faunal and fabulous subjects. Rams, lions, and boars (figure 46) take the place of frogs, monkeys, dogs,[207] and sphinxes. Sirens now proliferate, and dancers appear. Pendants in the form of detached heads, either of specific female divinities or other figures, are among the few traditional subjects to retain their important place, right through to the beginning of the fourth century B.C. Yet despite the change in iconography, the categories of appropriate subjects had not appreciably changed: they are still the protective and regenerative subjects of tradition, the subjects that could enhance or focus the powerful properties of amber.

A number of exceptional (unprovenanced) ambers can be dated to the sixth century based on their style and iconography. Among them are the Getty *Divinity Holding Hares* group (figure 47), the Getty *Ship with Figures* pendant (figure 9), a two-figure group in London, *Satyr and Maenad* (figure 19) (which is perhaps instead a dancing male and female?),[208] and a group of four pendant figures possibly from Ascoli Piceno, now in Philadelphia—two crouching nude males and an addorsed pair of draped female figures.[209] A recumbent lion, found in a circa 560–50 tomb at Taranto, is a rare example of a piece from a Greek colonial city.[210] These are "contemporary" works for their time, but they also evince artistic connections to older central Italic and Etruscan art, to the eastern Mediterranean, and to East Greek and Peloponnesian art. This wide range of influences might suggest simple explanations: itinerant carvers with a rich artistic vocabulary or a workshop in the ambient of a great crossroads. While both may be accurate, this line of thought underemphasizes the magical aspects of the imagery. What must be considered alongside such wide-ranging explanations is the significance of the imagery—the various iconographic ties are evidence of an "encyclopedia" of amuletic knowledge. A powerful explanation for the imagery of carved ambers is that they were made as amulets, or objects following a "prototype," recipe, or modeled according to tradition and prescription, requiring the practitioner to have absorbed various symbol systems and modes of representation. There must have been persistent types, and a long-lived oral tradition behind them. Because precision of execution is essential to efficacy, "magical practices have little potential for modification, change, and interpretation and thus tend to be slower to change than most other aspects of culture."[211] What Jaś Elsner queries from the starting point of a large-scale offering at Delphi is relevant here:

> In what sense is an image identical with the deity or activity it represents? The magical and theological properties of images, as well as the way the offering of the Orneatai could actually substitute as a ritual, hint at a much more dynamic

FIGURE 47

Divinity Holding Hares Pendant, Etruscan, 600–550 B.C. Amber, H: 9.7 cm (3⅕ in.), W: 6.4 cm (2½ in.), D: 2.4 cm (⁹/₁₀ in.). Los Angeles, The J. Paul Getty Museum, 77.AO.82. Gift of Gordon McLendon.

interpenetration of image and referent, representation and prototype, than we usually allow for in discussions of mimesis.... Here ... the context of the image asserts the actual presence of its prototype.[212]

In contrast to these "international style" works are a scattering of amber carvings markedly Ionian in style and dating to the second half of the sixth century. Where they were carved is not known for sure, but some have old provenances: Falconara, in the mid-Adriatic, for the amber *fibula* in New York (figure 26); Sala Consilina, for the flying-figure ambers in the Petit Palais; Armento, for a tiny *kouros* in the British Museum. Another small *kouros* in Paris and two of the Getty *Heads of a Female Divinity or Sphinx* (figures 20 and 48), works which likely come from the Italian peninsula, also fit here.[213] The Getty *Kore* (figure 49) and her animal companions, the ram and boar pendants (figures 32, 42, and 46), are additional evidence of the presence of Ionians in Italy, perhaps in one of the Etruscan cities where Ionian art was welcomed.

Three burials, rich in amber objects that date to the end of the sixth century, demonstrate the tradition (extending back to the Bronze Age) of burying strings of ambers in the tombs of elite females: at Sala Consilina, with three necklaces totaling a minimum of 114 pieces; in Tomb 102 at Braida di Vaglio with nearly 300; and at the "princely" tombs at Novi Pazar (Serbia), with over 8,000 individual amber beads, pendants, and related objects. In the Braida di Vaglio tomb, the skeleton is that of a young girl six to seven years old; the sex of the other two graves are assumed to be female.[214]

Fifth-century finds are more concentrated outside of coastal sites in Latium, Etruria, and Magna Graecia. They are dispersed among graves at the fringes of Etruria, in the mid-Adriatic, and in southern Italy in Campania, and today's Basilicata. A very large number of surviving figured ambers, mainly pendants, can be dated by context or style to the period of about the mid-fifth to early fourth century B.C. They range in subject from the now-traditional rams' heads, female figures, detached heads and faces, satyrs, to whole animals or mythological creatures in repose to more innovative images. The new subjects

100

FIGURE 48
Head of a Female Divinity or Sphinx Pendant, Etruscan, 550–520 B.C. Amber, H: 3.4 cm (1³⁄₁₀ in.), W: 2.4 cm (⁹⁄₁₀ in.), D: 1.6 cm (³⁄₅ in.). Los Angeles, The J. Paul Getty Museum, 76.AO.79. Gift of Gordon McLendon.

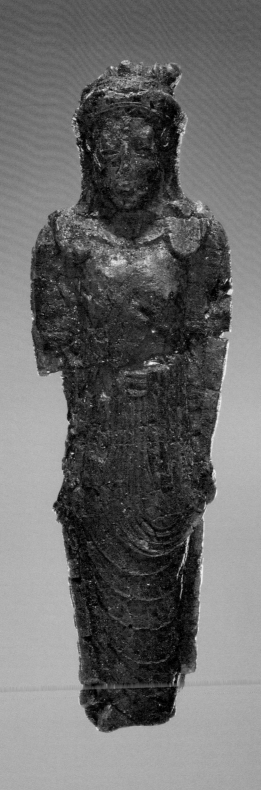

reflect the plurality of cultural and commercial relations established among Greeks, Etruscans, and other indigenous peoples, and many show the incorporation of new ways of attracting the good, averting the dangerous, or picturing the voyage to the afterworld and its guides. New to amber, but already established by this date in vase and wall painting, bronze work, and gold, all of which have come from graves, are action figures: Dionysian revelers vintaging or dancing,[215] a charioteer, a swaying Danaid, and figures in flight, sirens especially.[216] Athena with lion skin, shield, lance, is in movement: the Pyrrhic dance?[217] Aggressive subjects, of rape, imminent or active combat, or triumph over death emerge: Eos and Kephalos or Eos and Tithonos; Herakles killing the Nemean lion; or Achilles lying in wait.[218] Only in a few cases such as these can heroes and divinities be surely identified.

The style and iconography of the ambers of this period come out of the artistic traditions of Greece (including Magna Graecia), Etruria, and other Italic areas. Some heads have old-fashioned divine hairstyles and large, severe faces, conjuring up Near Eastern divinities. Most wear old-fashioned Etruscan dress, the significance of which deserves more attention. Generally speaking, the Archaic style has a secure hold throughout the fifth century B.C. and well into the fourth. Some works are very like other sculptural works and compare well with the *corpora* of ivories, bronzes, and terra-cottas. Others, significantly, are old-fashioned in style: many have the oversized eyes of much earlier art, kept alive in the millennia-old schemata of divine and heroic representations of the Near East, some are remarkably like Hittite sculptures. The huge eyes signify the figure's identity and the characteristic keenness of sight of the supernatural. Wide open and exaggerated, the eyes of the amber heads project a dazzling gaze, emphasizing the efficacy of their role as *apotropaia* or devices of protection or danger-aversion (figure 50).[219]

Nearly every subject represented in amber during this period has counterparts in other media found in Italy, namely sculpture, vases, gems, and even architectural decoration, Greek, Etruscan, and Italic. In some cases, individual objects or monuments have been related to ancestors, or clan, as well as to place, or cult.[220]

FIGURE 49
Standing Female Figure
(*Kore*) Pendant, Etruscan,
525–500 B.C. Amber,
H: 6.7 cm (2⅝ in.), W: 2 cm
(⁷⁄₁₀ in.), D: 0.9 cm (⅜ in.).
Los Angeles, The J. Paul Getty
Museum, 76.AO.77. Gift of
Gordon McLendon.

FIGURE 50
Female Head Pendant, Italic
or Campanian, 500–480 B.C.
Amber, H: 3 cm (1⅕ in.),
W: 2.6 cm (1 in.), D: .4 cm
(¹⁄₁₀ in.). Los Angeles, The
J. Paul Getty Museum,
83.AO.202.12. Gift of Vasek
Polak.

Rather than coming from Etruria proper, almost all fifth–fourth-century ambers are documented as coming from (or are believed to have been found in) areas with significant Etruscan connections: at sites north of the Po; in Campania; on the Italian mid-Adriatic seacoast; further inland in Basilicata, Lucania, and Calabria; and at Aleria (Corsica), and at Kompolje (Croatia). As is true for the earlier figured ambers from nonpeninsular finds (Novi Pazar, most importantly), those from Aleria and Kompolje are closely related to the Italian finds. Unfortunately, as is the case with the ambers from the eighth–sixth centuries, only a few of the ambers of fifth–fourth-century date have been included in the study or in some cases publication of the grave's skeletal material. None of the significant amber objects from chance finds, problematic excavations, and illicit undertakings are able to produce information about the sex of the inhabitant(s) and other critical contextual information. The admirable exceptions, including many recent excavations in the Basilicata, show that tombs with figured amber of the sixth–fourth century were female burials, with one certain anomaly, the man buried in Tomb 43 at Melfi-Pisciolo. All of the others belonged to adult women and girls. Figured pendants, in almost every case, were found on the upper torso, once the elements of neck and chest adornments, or in the pelvic area, originally girdle pendants.[221]

Many of the (well-published) fifth-century tombs with figured ambers from South Italy are critical evidence for the importance of amber to the inhabitants and for the funeral customs of the elite women of the populations—which reveal the continuation of certain late Bronze Age (indigenous) traditions and the impact of Magna Graecian and Etruscan culture in the interior through interaction with the more recent settlers of the Tyrrhenian and Ionian coasts. The link between amber and ritual, elite status and salvation is undeniable. Two exemplary tombs of elite Italic females might be singled out: the aforementioned late-sixth-century Tomb 102 from Braida di Vaglio (figure 6) and the late-fifth to early-fourth-century Tomb 955 from Lavello-Casino. Both contain not only significant pieces of figured

amber but also gold (a grape-cluster necklace in Tomb 955) and a rich selection of vessels and utensils for banqueting—for the mixing and drinking of wine, Italic and Greek traditions both being represented, and for the roasting and eating of meat.[222] The contents reveal a climate welcoming the worship of Dionysos in Italy, and perhaps the impact of Orphism.

Dionysian subjects had come into prominence in figured amber already in the sixth century, satyrs first, and then other imagery, many of the ambers expressly prepared for funeral rituals. These are powerful evidence for the importance of the resurrection divinity in folk religion and cult in Italy.[223] They, like the evidence in indigenous graves of banquet practices and sacrifice, denote an afterlife condition of beatitude, and the mysteries of Dionysos constituted one of the paths to salvation.[224] Amber could have illuminated the way.

Dionysos (figure 51) watched over Italy, as we hear from the chorus in Sophocles' *Antigone*: "God of many names … you who watch over far-famed Italy."[225] Dionysos, the god of dance and drama, not only of wine, who promised experiences outside the corporeal (*ecstacies*) was an obvious focus for individuals worried about the afterworld.[226] By the fifth century, as Susan Guettel Cole has observed, "the rituals of his cult were clearly associated with themes of life and death. Dionysos was a god whose myths about a double birth, death, and rebirth, and a journey to the underworld made him a figure attractive to those who wished to find a way to escape the anxieties of death."[227]

Dionysos also knew the great sea, where he plunged to avoid Lycurgus and was rescued by Thetis, and where he showed his powers as he transformed his Tyrrhenian pirate captors into dolphins. The liquid, especially the winelike, optical characteristics of amber may have made for a natural connection between Dionysos and the ancient resin. As E. R. Dodds writes in his edition of Euripides' *Bacchae*, "[Dionysos'] domain is, in Plutarch's words, the whole of *hugra phusis* [the principle of moisture], not only the liquid fire of the grape, but the sap thrusting in a young tree, the blood pounding in the veins of a young animal, all the mysterious and uncontrollable tides that ebb and flow in the life of nature."[228]

FIGURE 51
Head from the statue of the Young Bacchus (Dionysos), Roman, first half of the 1st century. Bronze with silver, H: 21.6 cm (8½ in.). Los Angeles, The J. Paul Getty Museum, 96.AB.52.

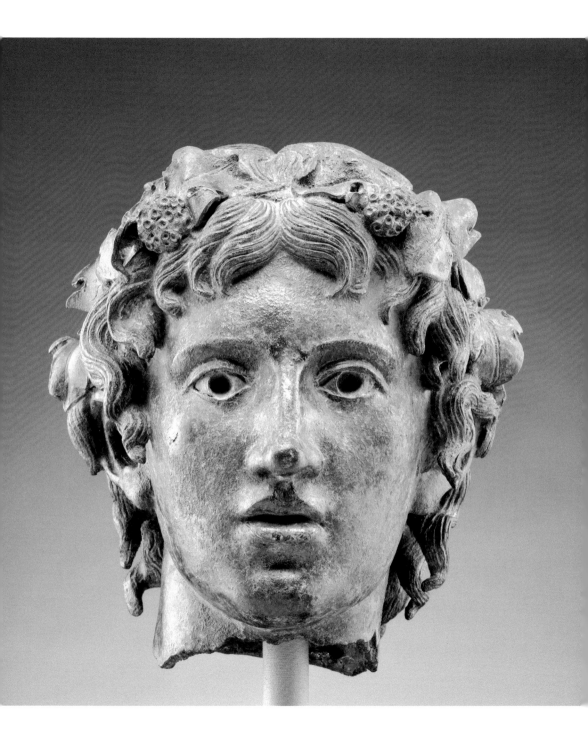

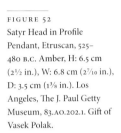

FIGURE 52
Satyr Head in Profile
Pendant, Etruscan, 525–
480 B.C. Amber, H: 6.5 cm
(2½ in.), W: 6.8 cm (2⁷⁄₁₀ in.),
D: 3.5 cm (1⅜ in.). Los
Angeles, The J. Paul Getty
Museum, 83.AO.202.1. Gift of
Vasek Polak.

FIGURE 53
Votive statue of Hercle,
Etruscan, 320–280 B.C.
Bronze, H: 24.3 cm (9⅝ in.).
Los Angeles, The J. Paul Getty
Museum, 96.AB.36.

Satyrs (figure 52), nymphs, Bacchic revelers, heads of the god, and other Dionysian subjects are among the most numerous of the funerary fifth-century figured ambers. And Dionysian subjects would be the most common of Roman-period figured ambers.[229]

Herakles (figure 53) in Greece and in Italy (in Etruscan, Hercle) was another powerful apotropaic figure because of his cultic roles as danger averter, healer, and death-dealer.[230] His polyvalent cult functions in Etruria and much of the Italian peninsula were also associated with trade, triumph, transhumance, and initiation; and he was worshipped in his oracular/mantic and founder roles.[231] The hero-god is represented in amber derived from various schemata—Greek, Etruscan, and

Cypriot. Two amber amulets of the Cypriot-type of Herakles show him wearing a lion's skin helmet: these were doubly potent, as the lion skin itself was a standard protective device.

The Homeric heroes Achilles and Ajax, both represented in amber, also had long-standing danger-averting, protective, and propitious roles in Greek and Greek-influenced culture. Achilles triumphed in arms (Achillean sharp-subject amulets "cut" pain). An amulet with Ajax, heroic rescuer of the fallen body of Achilles, who committed suicide by falling on his sword, but was said to live after his death in the island of Leuke, might also "cut" pain or offer protection.

Most importantly, Homer's very words were magical. Quotations from his work could heal people when whispered in their ears or hung around their necks written on amulets, which should be preferably of gold. Not only could Homer cure disease: he could also make fruit trees grow and favor peoples' relations with one another.[232]

Heroic and martial figures could play important roles in what is called aggressive magic.[233] Subject, material, and actions (such as attachment and incantation) were likely combined in the use of potent healing objects. The large amber pendant of Herakles stabbing the Nemean lion (blood spurting from the wound) in the Bibliothèque nationale might be explicated by the physician Alexander of Tralles' recipe for abdominal pain, or colic, which was to be given if a patient "would not follow a regimen or could not endure drugs." It reads: "On a Median stone [possibly red in color] engrave Herakles standing upright and throttling a lion; set it in a gold ring and give it to the patient to wear."[234]

The last moment in the pre-Roman period for the interment of amber is toward the end of the fourth century B.C. This is documented by a concentration of finds on the central Adriatic coast and in southern Campania. Three exceptional finds are those at Villalfonsina, Paestum, and Timmari: the subjects of the pendants are female heads or faces, joined into necklaces with spacer beads of various shapes.[235] The finds at Paestum date after the Lucanian takeover of the site, as Angela Greco Pontrandolfo pointed out—critical evidence for the appreciation of amber earlier among the Lucanians.[236] One of the latest examples of

these necklaces was found at Timmari and dates to circa 330–20 B.C.[237] From the period of the late fourth century until the first century A.D., amber is a scarce grave good in Italy. The exceptions are a number of gold earrings in the shape of helmeted heads (the negroid heads are of amber) of the third century B.C., many of them from Etruria.[238] Just as is the case with the earliest of Etruscan and Greek ambers, these late manifestations of funereal figured amber objects are tiny in scale. Yet their function is still to protect and to avert danger and, as fertile subjects, to promise rebirth. It is not until the revival of trade by the Romans that amber again became abundant in Italy. Figured amber objects, necklaces, rings, small vessels, and small, independent carvings once again become significant grave goods, particularly for women and children. Danger-averting gorgons, Dionysian and marine subjects, and other time-honored images of protection and regeneration dominate, continuing what was now a peninsular vocabulary for efficacious objects of amber.

THE WORKING OF AMBER: ANCIENT EVIDENCE AND MODERN ANALYSIS

There is no literary or archaeological evidence for specialized amber workers in pre-Roman Italy. Because of its inherent properties, it is likely that amber was worked by any number of skilled craftspeople, or artisans. Considering its magical and medicinal importance, amber must also have been worked by a multiplicity of ritual specialists-pharmacists, "wise women," priests or priestesses, by "those who had the knowledge."[239] However, for the working of very large carvings, or for amber *fibulae* composed from conjoined pieces, considerable experience with the varying qualities of amber was essential.

An artisan comfortable working other hard materials such as hard woods, ivory, or horn, or one skilled in cutting gems, would have found working amber comparatively undemanding. One had to know that the material is brittle and that to cut or drill amber, it is important not to have fractured or layered pieces; that it is important not to apply too

much pressure; that perforations have to be drilled from both sides toward the middle, or a hot metal needle is to be used to penetrate the resin; and that the low melting temperature requires the use of a cooling lubricant. An added benefit would have been that amber is pleasant to work, for it is fragrant, unlike ivory.

A number of scholars have proposed that amber would have been worked by ivory workers, citing the subjects, as well as the stylistic and technical evidence. Certainly, the tool marks on the objects show that eighth–fourth-century amber objects were made with a tool kit

FIGURE 54 A & B
Silver Pin with Amber
Satyr Head Pendant, Italic,
5th century B.C. Amber,
H: 6.8 cm (2⁷/₁₀ in.),
W: 4.9 cm (1⁹/₁₀ in.), D: 2.2 cm
(⅞ in.). Taranto, Museo
Archeologico Nazionale,
138144. Su concessione del
Ministero per i Beni e le
Attivita Culturali-Direzione
Regionale per i Beni Culturali
e Paesaggistici della Puglia–
Soprintendenza per i Beni
Archeologici della Puglia.

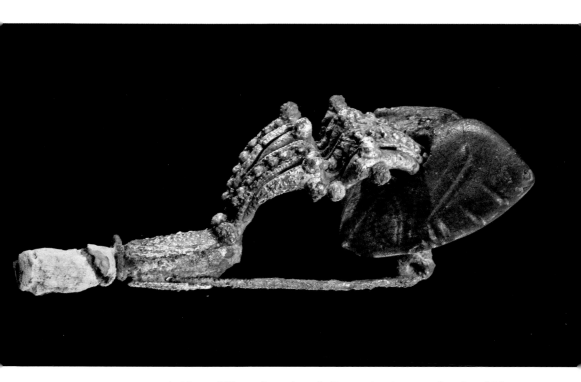

probably no different from that of a Bronze Age ivory worker, for which
there is excellent archaeological evidence.[240] (Much less is known
about the pre-Roman period.) In fact, the working of amber today has
changed very little, with the exception of the speed offered by elec-
tric tools. Like the Bronze Age tool kits, the pre-Roman ones would
have likely included bow drills, chisels, saws, knives or blades, points,
awls, burins, rule and compass, vices, abrasives, oils, metal foils, pig-
ments, and glues. The surviving evidence of amber from the Iron Age
and beyond—furnishings, armor, and utensils; boxes, vessels, dress
ornaments, and amulets—show that amber was in the supply of many
kinds of trained workers. Some composite works—furniture inlaid with
ivory and amber; ivory carvings inlaid with amber; bronze *fibulae* orna-
mented with amber (compare figure 54 A & B) and ivory; or amber
carvings embellished with ivory and precious metals—are additional
concrete evidence for the existence of artisans working in more than
one medium.[241] The evidence is also to be found in many surviving

multimedia works, such as one type of seventh-century *fibula*, made from ivory, amber, gold, and bronze, or a work such as the Getty *Head of a Female Divinity or Sphinx* (figure 48), an amber face with metal additions (silver?) and possibly, inlaid eyes.[242]

Many figured ambers, particularly those of the seventh–fifth centuries B.C., are similar in style to contemporary and earlier works in other media, such as gemstones, coins, terra-cottas, or bronzes. However, they are closest in manufacture, and often in subject, to objects of ivory or wood. The amber *kouros* in London is very close in form to a wood *kouros* excavated at Marseilles and to a pair of tiny ivory Etruscan *kouroi*.[243] The Getty plaque *Addorsed Lions' Heads with Boar in Relief* (figure 33) is very like an ivory relief. Works such as the exquisite chryselephantine "Artemis" and "Apollo" from Delphi[244] are among the closest parallels for the Getty *Head of a Female Divinity or Sphinx* (figure 48) and the Getty *Kore* (figure 49), not only for the style, but also for details such as the inlaid eyes.

The pre-Roman ambers themselves yield considerable evidence of their manufacture. The traces of working consist of carving, cuts, filed grooves, drill pointing and drilling rills, abrasion scratches, engraving, and fine burnishing. Supplemented by both earlier (Bronze Age) and later (Roman) physical evidence, medieval and early modern treatises, and still-current methods of amber working, a picture of their manufacture comes into focus.

The process of creating the objects likely began with a careful study of the piece of amber. Some ambers must have been worked from the raw state, others from preexisting finished works. In some cases, the raw material was treated as if it were any other costly material, and little trace exists of the natural form of the amber, whether drop, rod, or sheet. However, in other cases, the naturally occurring form of the ancient resin is retained, and sometimes even exploited in the finished object (the Getty *Hippocamp* (figure 55), the *Kourotrophoi* (figures 38 and 56), and *Lion* (figure 58) are good examples of this).

If the work were begun with a raw piece of amber still with its outer skin, or cortex, it would be necessary to remove this and any encrusted

FIGURE 55
Hippocamp Pendant, Etruscan, 575–550 B.C. Amber, L: 7 cm (2¾ in.), W: 4.3 cm (1⁷⁄₁₀ in.), D: 2.7 cm (1¹⁄₁₀ in.). Los Angeles, The J. Paul Getty Museum, 78.AO.286.1. Gift of Gordon McLendon.

material, organic matter, or shells. This was likely done with saws, abrasive powders, and water. The fissures would be cleared of organic matter and hard minerals, the pyrites. In amber working, water acts as both a coolant and a lubricant in the shaping, smoothing, and drilling processes since the ancient resin will soften or melt with the application of high friction.[245] The resulting surface of an amber blank was smooth but uneven, with craters and undulations. In the seventh century, an artisan might remove a large amount of material to attain the desired form; in fifth-century Italy, the design would be accommodated to the irregular (magical) shape. The twelfth-century A.D. guide to working crystal by Theophilus probably outlines the next steps that are corroborated by the tooling remains on both pre-Roman and Roman-period ambers. The medieval treatise states: "Rub it with both hands on a hard sandstone moistened with water until it takes on the shape you want to give it; then on another stone of the same kind, which is finer and smoother, until it becomes completely smooth."[246] Theophilus then suggests the use of a flat abrasive surface to sand the nodule. Evidence of this is found on the remarkably well-preserved, flat inside of the Getty pendant *Head of a Female Divinity or Sphinx* (figure 20).

The amber pieces must have been further abraded, carved, engraved, and polished into the desired subjects, perhaps refined with engraving (and more rarely, drilling). Sketching was likely done with a sharp scriber of metal, stone, or flint.[247] Pliny refers to *Ostacias* (flint?), which is "so hard that other gemstones are engraved with it."[248] Engraving required a rotating instrument, such as a bow drill, the standard tool of a gem engraver.

The narrow-bore suspension perforations, usually transverse, were drilled with particular attention to how the pendant would hang or would attach to a carrier. The narrowness of the borings suggests that the ambers would have been suspended from plant filaments, such as linen, or even silk. Many of the larger pendants have multiple long borings, again usually transverse, signifying that more than a simple filament was needed for the suspension, or that the pendant was part of a complex beaded apron, neck ornament, or girdle or was sewn

directly onto clothing. The large *Ship with Figures* (figure 9) and the Getty *Kourotrophos* group (figure 56) have multiple perforations and would have required more than one carrier, and a system of knots. The circa 600 B.C. multipiece pendant in Trieste[249] and the circa 500 B.C. composite pendants from Novi Pazar[250] were made possible by complicated stringing/knotting systems, all visible in the transparent amber.

Not only would the stringing have secured the pendants, but both the knots and the action of tying the knots were critical to amuletic usage. In magical practice tying a knot implies hindering negative actions. Demons and their corresponding diseases were believed to be caught by knots, bands, threads, strings, or amulets. Knots could thus actively play a protective or benevolent role. The pendant-amulets would have been tied on, attached, or suspended as an essential aspect of their efficacy, as we learn from ancient literary sources.[251] The large frontal holes of some figured works are secondary to the transverse perforations, and as discussed below, could be used to attach works to pins (figures 54 A & B) or even to a piece of furniture.

The final stage in the working was probably to polish the surface, likely with oil and a fine abrasive or cloth. To bring out the brilliance of the stone, Theophilus instructs: "Finally, put the tile rubbings, moistened with spittle, on a goatskin free of dirt and grease, which is stretched on a wooden frame and secured below with nails, and carefully rub the crystal on this until it sparkles all over."[252] This would bring up the luster and the fragrance. The polishing and rubbing would have released the ambrosial perfume of the amber; if that were not enough, the piece could have been rubbed with perfumed oils. We might imagine how this would have added to amber's attraction and mystery, especially if it were a divine image. The delicious odor might have "[matched] the emanation of fragrance that forms so regular a part of divine epiphanies."[253] As a divine characteristic, fragrance was itself imbued with the power of everlasting life.

All of the surviving pre-Roman figured ambers (at the Getty Museum and elsewhere) reveal an understanding of the morphological and structural characteristics of the ancient resin. Compositions tend to

be compact, without projecting parts; the potential points of weakness are minimized in the designs. In human figures, legs and feet are close together, arms and hands are attached to bodies, and necks are short; animals may have their legs tucked beneath, heads reverted, and tails curled around the haunches. The best-preserved works retain signs of surface burnishing, which once enhanced the optical qualities of the amber, its transparency, brilliance, luster, and color.

The earliest figured amber objects from Greece and Italy, dating to the eighth–seventh centuries, are small, from about 48 mm, and frequently imitate small-scale sculptural objects in other media, including ornaments and amulets. The Orientalizing amber carvings are comparable to works in ivory, bone, wood, faience, precious metals, gemstones, or bronze. Many appear to be direct translations into amber. Examples are the Egyptian and Egyptianizing scarabs, scaraboids, monkeys, dwarves, and other time-honored amuletic subjects. In these small works, there is no evidence of the natural shape of the amber, and little wastage. Some of the excess may have been used to make tiny beads or inlay, as flux in goldsmithing[254] or as incense or medicine. A number of pendants in the Getty collection, all dating to about the last third of the sixth century, correspond closely to objects of Ionian Greek (or Ionian-influenced) art. Among the finest examples are the two *Heads of a Female Divinity or Sphinx* (figures 20 and 48), the *Kore* (figure 49), and some of the ram's and lion's heads.

A different approach to the material emerged at the beginning of the sixth century B.C. The natural form of the amber nodule is preserved, even enhanced, by the design. Some objects, such as the Getty *Hippocamp* (figure 55), suggest that the lumpy nodule of amber may even have dictated the subject. The figures of the multifigure pendants are distorted as they wrap around the exceptionally large amber pieces. In order to comprehend the entire subject, the pendant needs to be physically turned in every direction. In any one view the figures are deformed, but as the pendant is turned, the shapes shift. The Boston *Dancing Youth* (figure 57) and the British Museum *Satyr and Maenad* (figure 19) are excellent illustrations of this. The compositions are

FIGURE 57
Dancing Figure. Etruscan
or Italic, early 5th century.
Amber, 7.2 × 3.7 cm (2¹³/₁₆ ×
1⁷/₁₆ in.). Museum of
Fine Arts, Boston. Gift of
Miss C. Wissmann, 02.254.
Photograph © 2011 Museum
of Fine Arts, Boston.

FIGURE 58 A & B
Lion Pendant, Etruscan or
Campanian, 525–480 B.C.
Amber, L (as preserved):
10.5 cm (4⅛ in.), L (estimated
original): 11.5 cm (4½ in.),
W: 4 cm (1½ in), D (at chest):
1.8 cm (⁷/₁₀ in.). Los Angeles,
The J. Paul Getty Museum,
76.AO.78. Gift of Gordon
McLendon.

illogical, the scale of the figures are skewed, parts are missing, the heads
and bodies are twisted or wrapped around the amber in an anatomi-
cally impossible manner. Is this because of the sanctity of the whole
piece of amber? Are the figures deformed as part of the magic, the
shape shifting as the object is turned over? Is this shape shifting—a
common demonic talent—part of the attraction?[255]

A variant of this approach is seen in a number of animal subjects, best exemplified by the Getty *Lion* (figure 58 A & B). In this work, there must have been no appreciable wastage. The natural form of the amber blank is obvious and the subject embellishes, rather than conceals, the idiosyncrasies of the raw material. In such cases the outline, depth, and undulations of the surface are incorporated into the design, with the result that animals and anthropomorphic figures are

compacted, splayed, or contorted.²⁵⁶ A few anthropomorphic pendants are worked in the round, but many have flattish, plain backs. Since the amber was transparent, the carving would have been visible from any angle, an extraordinary sight especially if the piece was figured on all sides. The reverse of the *Lion* allows it to be seen from below, a view only chthonic beings would have. These are extraordinary sculptural objects; in the ancient world, perhaps only in-the-round rock crystal carvings are comparable.²⁵⁷

There are precedents as early as the third millennium for the figural manipulation and contortion of pre-Roman amber objects. Many examples are to be found in the art of the Near East in objects dating to the fourth millennium and the Aegean Bronze Age. Ivories, amulets, and stone vessels are figure-wrapped. However, this is not common in Greek art. In Italy, the earliest parallels are in Etruria, in bronze vessel attachments and scaraboids. The outstanding examples of a wrap-around composition on large scale are the stairway sculptures of circa 560 from an altar(?) at the side of a clan tumulus at Cortona.²⁵⁸ The extreme examples of figure contortion are certain pre-Roman amber pendants, of which the earliest might be associated with the neighborhood of Cortona. Was it only to preserve as much of the amber as possible—not just because of amber's high value but also because of the efficacy of the resulting images? Might it also have been because such contortion was a way of magically "binding," or controlling, the potency of the subject? Were the subjects of the British Museum *Satyr and Maenad* (figure 19) or the Getty *Hippocamp* (figure 55) bound in order to strengthen their power?²⁵⁹

Many human and humanoid heads contain drillings, or stopped bores, many of which were filled with tiny amber plugs, on average 2–3 mm in diameter and 5 mm in length. These holes are located on the face, in the hair and headdress, on the neck, or on the obverse, but were never drilled into the facial features. Only sometimes are they found in areas with inclusions. It is not apparent why the holes were bored and then plugged. They may have been made to make the

pendant more consistently translucent, or to remove a microscopic bubble or an inclusion. Alternatively, the amber may have been drilled specifically in order to insert something into the bore, which was then plugged. Amulet making and medicinal recipes often include directions for inserting materials into another object.[260]

Many of the plugs are now missing, but the remaining ones are often darker and more opaque than the rest of the pendants. This is probably not an intended effect, but a result of a more accelerated oxidation of the plug.[261] The Getty *Asinine Head in Profile* (figure 59) has four large stopped bores, but none of the plugs remain. This pendant is full of inclusions, and the borings penetrate the inclusions. On the other hand, the Getty *Winged Female Head in Profile* (figure 40) has numerous stopped bores, some in areas with visible inclusions, while others in areas that appear to be inclusion-free.

A number of fifth–fourth-century amber pendants from South Italy have large holes (6 mm–12 mm) drilled in the center of the pendants. Four examples are still attached to large *fibulae*.[262] The large holes disfigure the design and must have been drilled after the carving was finished, perhaps much later. In the case of four other pendants, including a satyr head (figure 54 A & B), which retains its silver *fibula*, the holes are incorporated into the design, which implies that the perforations preexisted the figural composition. The large holes may have originated in the formation of the amber (the resin formed around a small branch) or in a previous use: the pendants might be carved from older works, perhaps large plain beads or pin decorations. It is also possible that these large holes were made to remove inclusions, or to insert something into the amber—both practices commensurate with magico-medical practice. Alternatively, the secondary perforations may have been drilled to destroy the power of the image.

THE PRODUCTION OF FIGURED AMBER OBJECTS

As a result of unauthorized archaeological activity since at least the nineteenth century, a great number, perhaps the majority, of sixth-to-fourth-century figured ambers are undocumented or without sure provenance. This places greater importance on works with solid documentation for a discussion of culture and meaning. It is often the case that find-spot is equated with place of origin, and grave goods are associated with ownership by the deceased or assumed to offer direct evidence of daily dress and customs. The existence of high-value objects such as amber and gold in elite graves must be considered in light of their role as ingredients in a larger network of cultural relationships. Amber and gold, incense, and precious textiles were internationally recognized prestigious and valuable objects, suitable for exchange, gift-giving, and status display. Not all objects were new; they may have been tokens of guest friendship; heirlooms; or funerary gifts from family or clan members, or from other relationships. Such "antiques" may have been valued for their history, provenance, or established efficacy (sacral, magical, or medicinal). Celebrations of alliances, marriages, and other rituals were likely occasions for the gathering, exchange, special commissioning, and social display of such objects. Where aristocratic Greek culture had resonance, some ambers may have been highly prized prestige objects—treasure gained from purchase, plunder, or presentation—and meant to be circulated within an aristocratic network. Emporia, palaces, or possibly sacred sites might support established as well as itinerant artisans. And the gifting of things, old and new, could not have been a rare occurrence in the pre-Roman period when amber reigned. A craftsman might have been a kind of gift, too. Travel and travelers (for reasons of commerce, politics, religion, or celebration) meant gatherings of people at sanctuaries and "princely" centers, where high-status objects might be purchased or commissioned, and where jewelry, magic, or medicine may have been procured. The role of "'cultural clearing houses,' the intermediate centers where goods and ideas were received, adapted, mixed—and passed on,"[263] such as that enjoyed by Pithecoussai and Rhodes in earlier centuries, or by a

FIGURE 59
Asinine Head in Profile
Pendant, Italic, 500–400 B.C.
Amber, H: 4.8 cm (1⅞ in.),
W: 5.9 cm (2³⁄₁₀ in.), D: 1.9 cm
(¾ in.). Los Angeles,
The J. Paul Getty Museum,
77.AO.81.24. Gift of Gordon
McLendon.

city such as Vulci in the sixth century are important examples to consider. The extent to which the existence of such centers had resulted in a web of autonomous secondary routes—along with a whole range of other cultural outcomes[264]—demands our attention, especially with a mythic material such as *elektron*. An indigenous palatial center such as Braida di Serra di Vaglio (Potenza, Basilicata) is an Italic example of where the "circulation" of both objects and people, and interchange between foreigners and colonial Greeks and Etruscans with the indigenous population, might be found. Traders and makers of amber might include residents as well as itinerants.

It is important to say a word about style: the efficacy of pre-Roman ambers may have been determined in part by the resin's assured provenance (from the North), by the form (it should follow established guidelines, or a prescription), and by having the appropriate style(s). The very duration of time-honored forms and style—the long life of Egyptian subjects and forms in amber, or the importance of Ionian- and Etruscan-looking ambers deep into the fourth century B.C.—underlines the conservative functions of figured ambers. It was seemingly important that works look like they were made by, or following the prescriptions of Egyptians, Ionians, or Etruscans. This visual resemblance, perhaps a stamp of authenticity, may have assured their potency or "branded" the magic of the objects. In this way, the style, "a way of doing things,"[265] is a culturally significant variable. In the case of amuletic ambers, the style can be said to play a critical role in defining the genuineness and efficacy of the objects. In addition, there appear to be prototypes, not only schemata, but actual models, that are followed for centuries. It is possible that certain works were in view for a long period, through the public display in ceremonial circumstances or via circulation. If some works were family or clanic heirlooms, their value may have been for one or more reasons, economic, sacral, medical, or magical. To find individual style in a copy of a copy is a challenge indeed.

In a search for the artistic origins of some figured ambers, scholars have tended to look for individual hands, schools, and centers of pro-

duction. Connoisseurship and archaeological sleuthing have resulted in the identification of master artisans. Much progress has also been made in siting some groups of objects, drawing them around schools or the hand of particular artisans, and there are undeniable stylistic connections between groups of carved ambers.[266] However, there are many reasons to consider paradigms that move beyond individuals, workshops, and centers of manufacture. As touched on above, many students of figured ambers have seen an undeniable Etruscan connection in the subjects and in the "art" of these objects. Some have emphasized Campanian or South Italian or Magna Graecian elements. This author has long advocated for the Ionian, and even more specifically the Milesian, aspects of many amber pendants.[267] Other scholars, notably Negroni Catacchio, have charted well-stated arguments for several regional centers.[268] Canosa, to name but one, is a good candidate for the fifth century B.C., as Angelo Bottini has argued.[269] Armento is another.[270]

But why (and where) in these centers? Was there a religious site or sacred sanctuary there? A market? A venerable studio? A school of pharmacology? Raw materials and finished products were easily portable, and not only was the use of amber amulets pervasive, but the iconography of some types—the pendant in the form of a detached head (figure 60), to cite the most numerous—was consistent over time. There is also evidence that carvings of different date and style could be buried together—as in the grave of the young girl from Tomb 102 at Braida di Vaglio.[271]

The great potency of amber made it the province of healing specialists, too. Although it is possible that itinerant craftsmen produced the amber carvings of pre-Roman Italy, and that they did so in court settings, as has been proposed,[272] these hypothetical models emphasize the craft and deemphasize the special function of figured amber objects in medicine, magic, and mourning.[273]

The terms *craftsman* and *artisan* imply *métier,* instruction, apprenticeship, or training, and the production of *art*. It must be kept in mind that amber is relatively soft and easy to work and was not, of

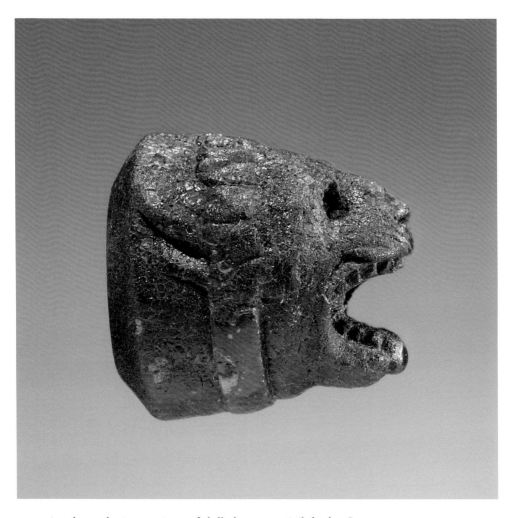

necessity, the exclusive province of skilled artisans. While the Getty
pendant *Head of a Female Divinity or Sphinx* (figure 48) may be equal
to the finest of contemporary temple dedications or cult imagery of
the period, many figured ambers are art only by modern definition.
The material was the force behind its usage, and therefore, the workers
of amber might well encompass pharmacists; religious functionaries,
including priests or priestesses; magicians; healers; seers; mid-wives,
or sorceresses.[271] Each piece must be interrogated: was it an heirloom,
a gift, an exchange object? Or was it produced and/or purchased at a

time of crisis? What was most important about these objects was *how well they worked:* as social indicators, as prestige objects, as gifts, as items in transition rituals, as ornamentation, as *materia medica,* and as amulets. Amuletically, the knowledge about the incantations necessary to accompany them and their specific magical role was essential. Any analysis of how they functioned for the living and the dead needs first to consider who would have possessed such information.

This is especially important when it comes to the most long-lived and geographically widespread of the amulet types, of which a substantial number (early as well as late) are schematic in manufacture. The sixth-century female heads from Eretum, for example, are small and primitive, with features formed primarily by abrasion.[275] Such is also the case with a number of crude heads in the Getty collection. Since both the material and the subjects of pre-Roman amber amulets suggest an association with healing, with the protection of women, infants, and children, and with the aversion of danger, it may be that some were acquired at the sanctuaries of healing divinities, where old traditions were kept alive or powerful images were on view in special settings or ceremonies. Some pieces may have also been spoils, gifts, or dedications.

There is much to be learned about the making of power objects, jewelry, and amulets from Egypt and Mesopotamia, where the literary sources and the archaeological evidence are especially rich, and from the later Greek tradition of inscribed amulets, among the earliest of which were found in South Italy. With noninscribed amulets, the situation is more complicated, and more open to misinterpretation. Nevertheless, information can be mined from earlier, concurrent, and later traditions. Especially valuable are ancient amulets with writing on them, which appear with frequency in Roman times as well as the ancient handbooks with instructions for the preparation of rites and amulets. These reveal a great deal about the workings of amulets: the stated purpose, the ingredients, the time and place for performance, accompanying gestures, and the incantations themselves. For specific objects, however, we still may never know: "Was the preparation,

inscription, or donning of the amulet conceived or enacted as a ritual act or in a purely perfunctory manner?"[276]

The different possibilities for who made the amber pendant heads and in what kind of context are not necessarily mutually exclusive. A female head pendant excavated at Lavello may be a local product, for it has formal connections with earlier Etruscan art, with the art of Laconian Taranto, and with local Italic production as Cecilia D'Ercole has shown.[277] Was it carved by a local artisan who has offered up the key elements of the image in her/his own style? What was the model? How old was it and where was it seen? Or was it made by an itinerant who had absorbed a large visual vocabulary, sculptural repertoire, or pharmacopoeia—whatever the correct lexicon may be. And made according to which traditions, and which kind of "instructions"? Another example might be a group of pendants in the form of frontal female heads in the British Museum, found together(?) at Armento in inland South Italy, which are thought by some scholars to be Campanian, or made under Campanian influence as was Donald Strong's opinion.[278] In each of the two cases, the heads may have been produced at a sanctuary of the divinity represented in the amber, by a local carver as a commissioned good, by an itinerant, for the open market, or even as filled "prescriptions." These heads, like all amber amulets, were valuable in every sense, and part of that value may have been where or by whom they were made. And they were just the sort of thing to have accrued further value by being displayed, worn, or buried at a place distant from their manufacture.

Carved ambers may have had many lives, and were involved in many activities. A figured amber pendant may have been in the pouch of an itinerant healer before being traded or gifted elsewhere, to be copied or remembered before it was placed in the tomb of a woman or child. Were the objects of this book property of a deceased person? Objects of mourning? Or were they grave gifts? Made from a material as old as the earth, formed into deeply significant subjects only to be interred once again, these gems of the ages offer new windows on the ancient world.

Notes

1 R. White, "Systems of Personal Ornamentation in the Early Upper Palaeolithic: Methodological Challenges and New Observations" in *Rethinking the Human Revolution: New Behavioural and Biological Perspectives on the Origin and Dispersal of Modern Humans*, ed. P. Mellars et al. (Cambridge, 2007), pp. 287–302. Herein White publishes the earliest known amber pendant, excavated from the Archaic Aurginacian level 4c6 att, Isturitz, France.

2 Strong 1966, pp. 10–11.

3 In 2002 thirty-five ambers in the Getty collection were identified as Baltic amber by Michael Schilling and Jeffrey Maish. See Addendum by Schilling and Maish in the online catalogue *Ancient Carved Ambers in the J. Paul Getty Museum*; see also Barfod 2005; Langenheim 2003; Serpico 2000; and Ross 1998; and Barfod 1996.

4 See S. P. Morris, *Daidalos and the Origins of Greek Art* (Princeton, 1992), esp. pp. 27–29; Steiner 2001, pp. 20–21; F. Frontisi-Ducroux, *Dédale: Mythologie de l'artisan en Grèce ancienne* (Paris, 2000); G. F. Pinney, *Figures of Speech: Men and Maidens in Ancient Greece* (Chicago, 2002), p. 53; Keesling 2003, p. 10; and M. C. Stieber, *The Poetics of Appearance in the Attic Korai* (Austin, 2004).

5 Andrews 1994, p. 6. The literature on amulets, amuletic practice, magic, and ritual practice in the ancient world is vast. The term *magic* is used here in its broadest and most positive sense. Following Kotansky 1991, n. 5, I use *amulet* to encompass the modern English *talisman* and also *phylaktērion*.

6 Dickie 2001, p. 25, and passim.

7 Reference from E. Thomassen, "Is Magic a Subclass of Ritual?" in Jordan et al. 1999, pp. 55–66.

8 Pliny, *Natural History, Books 36–37*, trans. D. E. Eichholz, Loeb Classical Library 419 (Cambridge, 1962), is the edition used throughout this text.

9 J. Evans, *Magical Jewels of the Middle Ages and the Renaissance, Particularly in England* (Oxford, 1922), p. 13.

10 The subjects and the forms of many pre-Roman figured ambers have precedents thousands of years older.

11 S. Eitrem, *Opferritus und Voropfer der Griechen und Römer* (1915; repr., Hildesheim and New York, 1977), p. 194, discusses the amuletic virtues of amber in Rome.

12 On Egyptian amulets, see Pinch 1994 and Ritner 1993.

13 K. Benzel in *Beyond Babylon* 2008, p. 25, with reference to pp. 350–52 in the same catalogue.

14 Amber itself, and most of the subjects of figured amber, have fertility aspects. An important aspect of fertility magic is the *control* of reproduction (e.g., birth spacing) rather than procreation. See G.-H. Luquet, *L'art néo-calédonien; documents recueillis par Marius Archambault* (Paris, 1926) and P. Ucko and A. Rosenfeld, *Paleolithic Cave Art* (London, 1967) on the limiting of population rather than its increase.

15 Frankfurter, *Bryn Mawr Classical Review* 95.04.12 (review of Kotansky 1994).

16 The literature on gifts and gift giving in the ancient world is extensive.

17 Thomassen 1999 (note 7 above), p. 65.

18 Faraone 1992, p. 37, suggests that all protective images, whatever their "'original' purpose or the specific crisis that led to their manufacture" might eventually become an "'all-purpose' phylactery against any and all forms of evil."

19 See note 147 below.

20 The scenario of multiple ritual specialists recorded by the tenth-century compiler Ibn al-Nadim, who pronounced Egypt "the Babylon of the magicians," might provide a later model for pragmatic ritual

expertise at all levels and the range of activities of itinerant artisans and healers in pre-Roman Italy.

21 Langenheim 2003, p. 169. See now A. P. Wolfe et al., "A new proposal concerning the botanical origin of Baltic amber," *Proceedings of the Royal Society, Biological Sciences*, vol. 276, no. 1672 (October, 2009), pp. 3403–12, for the argument that, "conifers of the family Sciadopityaceae, closely allied to the sole extant representative, *Sciadopitys verticillata*, were involved in the genesis of Baltic amber."

22 Ross 1998, p. 2.

23 Nicolson and Shaw 2000, p. 451, with reference to Beck and Sherman 1991, pp. 16–17.

24 Ross 1998, p. 3: "The polymers are cyclic hydrocarbons called terpenes…amber generally consists of around 79% carbon, 10% hydrogen, and 11% oxygen, with a trace of sulphur."

25 Ross 1998, p. 3.

26 Grimaldi 1996, p.16.

27 Langenheim 2003, pp. 144–45.

28 Langenheim 2003, p. 146, following Anderson and Crelling 1995.

29 Ross 1998, p. 3, in describing the amberization process, points to the critical element played by the kinds of sediments in which the resin was deposited, "but what is not so clear is the effect of water and sediment chemistry on the resin."

30 Ross 1998, p. 12.

31 Langenheim 2003, p. 150.

32 Langenheim 2003, p. 164.

33 See the overview of the mining of Baltic amber in Rice 2006, ch. 3.

34 The geological source of Ming and Ching Dynasty amber carvings is not assured; the amber may have come from Myanmar (Burma), possibly from European, "Syrian," or Chinese sources.

35 Ross 1998, p. 11.

36 For the basic properties of amber, see Ross 1998, p. 4. The word *electricity* was coined by W. Gilbert, physician at the court of Queen Elizabeth I, to describe this property in his 1600 book on magnetism, *On the Magnet, Magnetic Bodies and that Great Magnet the Earth*. The early Greek philosopher Thales of Miletos is credited by Diogenes Laertius as the first to recognize amber's magnetism.

37 Clear colorless glass (with antimony used for the decolorizing agent) is documented in the eighth century in western Asia and again in the fifth and fourth centuries in Greece.

38 For an excellent overview of lenses and their ancient employment, see Plantzos 1999, pp. 39–41, 110, and D. Plantzos, "Crystals and Lenses in the Graeco-Roman World," *AJA* 101 (1997): 451–64. Although no ancient literary source mentions amber's natural magnifying property, it is difficult to imagine that it went unnoticed. In 1691, C. Porshin of Königsberg invented an amber burning glass, which was said to be better than the glass kind; he also used amber to make spectacles; see O. Faber, L. B. Frandsen, and M. Ploug, *Amber* (Copenhagen, 2000), p. 101.

39 See Ross 1998, pp. 18–19; and Strong 1966, p. 14 (with reference to M. Bauer, *Precious Stones* [London, 1904], p. 537).

40 Ferrara, Museo Archeologico Nazionale 44877–78, from Tomb 740 at Spina: C. C. Cassai, "Ornamenti femminile nelle tombe di Spina," in *Due Donne* 1993, pp. 42–47.

41 For splendid photographs of the Verucchio material, see *Dono delle Eliadi* 1993.

42 Strong 1966, pp. 61–62, pl. xv.

43 Plantzos 1999, p. 41, on the importance of color to ancient gemologists.

44 *Agalma*, perhaps related etymologically to *aglaos* (shining), is one word used in Greek to describe the quality of brilliance. See Stewart 1997, p. 65.

45 Foil- or metal-backed amber is mirror-like. How an amber "mirror," however tiny, worked for the living or for the dead is worth reflection.

46 Winter 1994, p. 123.

47 The word *elektron* was also used in antiquity to describe the alloy of silver and gold (modern electrum). Both the fossil resin and the alloy are found in the Shaft Graves at Mycenae, but the earliest surviving source to discuss both materials is Herodotus. Naturally occurring alloys were likely used alongside manmade ones.

48 Huld 1997, p. 135.

49 Homer, *Iliad* 6.513, 19.398.

50 Tacitus, *Germania* 45.

51 Another old German word for amber is the oberdeutsch *Agtstein* (from *aieten*, to burn).

52 E. Schwarzenberg, *Crystal* (private publication, 2006), p. 36.

53 In early Greece, as earlier in Egypt and the Near East, gods and some heroic figures are described with adjectives translated as bright, golden, shining, luminous, or glistening.

54 On *elektron* in the *Odyssey*, see A. Heubeck, S. West, and J. B. Hainsworth, *A Commentary on Homer's Odyssey* (Oxford, 1988), vol. 1, p. 197.

55 Homer, *Odyssey* 4.71–75. Others question whether this passage refers to the ancient resin or to the metal.

56 Homer, *Odyssey* 15.455–62.

57 Homer, *Odyssey* 17.294–96.

58 Hesiod, *The Shield of Herakles* 2.141.

59 R. A. Prier, *Thauma Idesthai: The Phenomenology of Sight and Appearance in Archaic Greek* (Tallahassee, Fl., 1989).

60 Theophrastus, *De Lapidibus* 5.28–29.

61 Theophrastus is not the only expositor of this story. Pliny dismisses a number of variations, including a belief held by Sudines and Metrodorus that amber comes from a "lynx" tree in Liguria.

62 Strabo, *Geography* 4.6.2–3.

63 Plantzos 1999, pp. 15–17.

64 Schwarzenberg 2001, p. 56, and Riddle 1965, passim, discuss additional names for amber which derive from its electromagnetic properties.

65 Pliny, *Natural History* 37.12.

66 For Dioscorides' discussion of amber, see Riddle 1965 and J. M. Riddle's later publications on the subject, including "*Pomum ambrae*: Amber and Ambergris in Plague Remedies" in *Quid pro quo: Studies in the History of Drugs* (Hampshire, Great Britain, 1992) pp. 3–17, 111–12.

67 Homer, *Iliad* 19.398 (R. Lattimore, trans., *The Iliad of Homer* [Chicago, 1961]). Greek poetry emphasizes brightness or sheen rather than hue as C. Irwin, *Colour-Terms in Greek Poetry* (Toronto, 1974), was among the first to emphasize. C. W. Shelmerdine, "Shining and Fragrant Cloth in Homeric Epic," in Carter and Morris 1995, pp. 99–107, opens the way for larger implications of her argument.

68 Quintus Smyrnaeus, *The Fall of Troy* 5.623–25 (A. S. Way trans., Loeb Classical Library 19 [London, 1913]).

69 Pausanias, *Descriptions of Greece* 5.12.7–8 (W. H. S. Jones and H. A. Ormerod, Loeb Classical Library 188 [Cambridge, MA, 1966]).

70 For the Roman preference for a reddish cast in yellow, see Gage 1993, p. 272, n. 74. On the affinity of red and gold in Egypt, see Wilkinson 1994, pp. 106–7. For the Egyptians, pure gold, its pigment cognate, yellow, and the color red were the colors of the sun; gold was symbolic of that which was eternal and imperishable. For the classical world, see Gage 1993, p. 26. Red-yellow, bright yellow—these terms might also be used to describe amber, and the connection may be a critical one, since amber is attested as a gift for brides.

71 Gage 1993, p. 26, with bibl.

72 For discussion of the poetic and symbolic vocabulary for the different colors of gold, see for example P. R. S. Moorey, *Ancient Mesopotamian Materials and Techniques: The Archaeological Evidence* (Oxford, 1994), p. 218.

73 Plantzos 1999, p. 36: "The shape in which a stone was going to be cut was also sometimes determined by its colour."

74 Falernian wine, product of Campania, was among the most prized in ancient Rome, and as Pliny writes, the second best wine produced in Italy (Pliny, *Natural History* 14.8 and 62). While wine is associated with Dionysos (and the Egyptian Bes), honey is associated with the Olympians Zeus and Artemis.

75 See Plantzos 1999, pp. 36, 89. For the use of garnets, hematite, and other red stones for martial subjects, see note 218 below.

76 On being both fragrant and shining, see Shelmerdine (note 67 above). On amber-fragrant kisses, see Martial, Juvenal (see note 109 below).

77 Steiner 2001, p. 101, with reference to N. J. Richardson, *The Homeric Hymn to Demeter* (Oxford, 1974), p. 252.

78 Herodotus, *Histories* 3.115.

79 Herodotus, *Histories* 4.32–36.

80 F. M. Ahl, "Amber, Avallon, and Apollo's Singing Swan" *AJP* 103 (1982) 373-411, esp. p. 378.

81 Apollonius, *Argonautica* 4.611–18.

82 For the funeral of Achilles (*The Fall of Troy* 5.583–85), see *Quintus of Smyrna: The Trojan Epic; Posthomerica*, trans. and ed. A. James (Baltimore, 2006). For the funeral of Ajax (*The Fall of Troy* 5.625–30), the translation is by A. S. Way (see n. 68 above).

83 This Phaethon is not the only Phaethon of Greek myth; see, for example, J. Diggle, *Euripides' Phaethon* (Cambridge, 1970).

84 Pliny, *Natural History* 37.11.

85 Ovid, *Metamorphoses* 1.750–2.380. See the extensive discussion of Euripides' *Hippolytus* and *Phaethon* in Diggle 1970 (note 83 above).

86 Diodorus Siculus, *Library of History* 5.23–24.

87 The story may have had particular relevance in Italy (especially in Etruria), a land famous for its fierce boars.

88 *On Marvellous Things Heard* 81–82.

89 See Mastrocinque 1991, pp. 16–22; Dopp 1997; and Geerlings 1997 for further discussion of the planetary and celestial aspects of Phaethon.

90 "Panegyric on the Sixth Consulship of the Emperor Honorius," in Claudian, vol. 2, trans. M. Platnauer, Loeb Classical Library 136 (Cambridge, 1922).

91 A. Ross, *Pagan Celtic Britain: Studies in Iconography and Tradition* (London, 1967), p. 234 (quoted in Ahl 1982 [note 80 above], p. 390).

92 Metropolitan Museum of Art 17.190.2067. Gift of J. Pierpont Morgan, 1917. Richter 1940, p. 31, figs.97, 98; Kredel 1923–24; and Albizzatti 1919.

93 Jannot 2005, p. 58.

94 Aristotle, *Meteorology* 4.10; Pliny specifies ants, gnats, and lizards, the first two signifying similar-appearing and excellent specimens; Tacitus, *Germania* 45.

95 Martial, *Epigrams* 5.32; 4.59; 6.15 (vol. 2, ed. and trans. D. R. S. Bailey, Loeb Classical Library 95 [London and Cambridge, MA, 1993]). See P. A. Watson, "Martial's Snake in Amber: Ekphrasis or Poetic Fantasy?" *Latomus* 61 (2001): 938–43.

96 See Ross 1998, pp. 6–9 ("fake amber"); Grimaldi 1996, pp. 133–41 ("processed amber, imitations, and forgeries"); A. Shedrinsky et al. "Forgeries of Fossils in 'Amber': History, Identification, and Case Studies," *Curator* 37 (1994): 251–74.

97 P. R. S. Moorey, "Blue Stones in the Ancient Near East: Turquoise and Lapis Lazuli," in Caubet 1999, pp. 175–88.

98 For amber in Tutankhamen's tomb, see S. Hood, "Amber in Egypt," in Beck and Bouzek 1993, pp. 230–35.

99 Juvenal, *Satires* 5.38, describes an encrusted amber cup and Apuleius, *Golden Ass,* 2.2.12, 19, speaks of large cups.

100 For discussion of amber imitations, see, for example, Langenheim 2003 and M. Ganzelewski, "Bernstein–Ersatzstoffe und Imitationen," in *Bernstein—Tränen der Götter* 1996, pp. 475–82.

101 Codex Forster 3, fol. 33v.

102 Tao Hung Ching, *Collection of Commentaries on the Divine Husbandman's Classic of Materia Medica, based on Shen Nung's Pen Ts'ao Ching* (reference from Langenheim 2003, p. 279).

103 O. Muscarella, *The Lie Became Great: The Forgery of Ancient Near Eastern Cultures* (Groningen, 2000) and A. T. Olmstead, "Amber Statuette of Ashur-Nasir-Apal, King of Assyria (885-860 B.C.)," *Bulletin of the Museum of Fine Arts* [Boston] 36 (1938): 78-83.

104 For the Paris statuette, see references for the Getty statuette *Seated Divinity* (cat. no. 57) in the online catalogue *Ancient Carved Ambers in the J. Paul Getty Museum.*

105 The unworked pieces found in early dwelling caves are far from the natural sources of the fossil resin.

106 Not all students of the material agree that it was traded in both finished and unfinished form.

107 Pliny, *Natural History* 37.11.

108 J. Kolendo, *A la recherche de l'ambre baltique: L'expédition d'un chevalier romain sous Néron* (Warsaw, 1981).

109 Martial, *Epigrams* 5.37.11. In 3.65, Martial compares the kisses of Diadumenus to "well-worn amber" and those of another (unnamed) youth to "amber thaw'd in a virgin's hand" in 11.8.

110 Fronto, "On speeches" (Marcus Cornelius Fronto, *Correspondence 1*, trans. C. R. Haines, Loeb Classical Library 112 [Cambridge, 1919]).

111 Pliny, *Natural History* 37.12.

112 Pliny, *Natural History* 22.99.

113 Pliny, *Natural History* 37.12.

114 Tacitus, *Germania* 45.

115 Strong 1966, p. 24, citing A. Bonarelli, "Le ambre nelle tombe picene," *Rendiconti dell' Istituto Marchigiano di Scienze, Lettere ed Arti* 3 (1927): 67-70. Marconi 1933, col. 409, cites the use of amber as fuel at Belmonte Piceno; Strong records such a use in the Perugia district.

116 Barfod 1996, p. 453, and J. Barfod, "Von der Heilkraft des Bernsteins," in Barfod et al. 1997, pp. 84–87. Amber's combustibility and its corresponding application of being burnt is suggested by at least two of its ancient names—*sualiternicum* and

thium. On the ancient use of resins in incense, see Langenheim 2003, chapter 8.

117 Black and Green 1992, p. 109.

118 J. M. Todd, "Baltic Amber in the Ancient Near East: A Preliminary Investigation," *Journal of Baltic Studies* 16 (1985): p. 292.

119 Shennan 1993, p. 201; Bouzek 1993, p. 14. The use of amber as a "gemstone" occurred at the same time in the eighth and seventh centuries in Greece and Etruria alongside other "well documented Near Eastern practices such as incense-burning, purificatory rituals, hepatoscopy, and the use of foundation deposits in temples": Faraone 1992, pp. 26–27.

120 Black and Green 1992, p. 109.

121 For the amber and other resins surrounding the corpse in the Grotta della Sedia, Banditaccia Necropolis, Cerveteri, see G. Dennis, *The Cities and Cemeteries of Etruria* (London, 1848), vol. 2, p. 59, n. 4.

122 Black and Green 1992, p. 109. Burning and offering incense as a means of communication between the earthly and divine spheres is first attested in the Pyramid Texts of the third millennium and remained a central cult act in Egyptian temples erected by Greek and Roman rulers. For Mesopotamia, see for example, B. Böck, "'When you perform the ritual of 'rubbing': On Medicine and Magic in Ancient Mesopotamia," *Journal of Near Eastern Studies* 62, no. 1 (2003): 10.

123 E. A. Smith, "Concerning Amber," *American Naturalist* 14, no. 3 (March 1880): 106.

124 This practice is documented in Old Babylonian times; see Black and Green 1992, p. 109.

125 Foster 2001, pp. 43–45.

126 The amber figurines in the graves of certain northern Costa Rican peoples living there circa A.D. 700–1400 have been interpreted as grave offerings. Langenheim 2003, p. 282, cites C. S. Balser, "Notes on Resin in Aboriginal Central America," in *Akten des 34. Internationalen Amerikanisten Kongress* (Vienna, 1960), pp. 374–80, who "suggested that these figurines could have been intended for burning as incense after death."

127 Unworked lumps have been found in several Etruscan tombs (see note 121 above).

128 Pliny, *Natural History* 37.11. In many regions of Italy, it was popular to present amber necklaces to young women, as their first precious object and as a *portafortuna* (Negroni Catacchio 1989, p. 659).

129 Compare, for example, the Egyptian text: "The infant is protected by the gods, the child's name, the milk he sucks, the clothes he wears, the age in which he lives, the amulets made for him and placed around his neck": F. Lexa, *La Magie Dans l'Égypte antique de l'Ancien Empire jusqu'à l'Époque Copte* (Paris, 1925), vol. 2, pp. 32–33.

130 Caesarius, *Sermons* 13.5, 14.4. See also Dickie 2001, pp. 304–5. Dickie suggests that the amber amulet "may well have had writing on it, or a magical symbol."

131 For a selection, see Strong 1966, nos. 119–23 (including ring pendants).

132 Strong 1966, p. 12.

133 Kotansky 1991, p. 113.

134 Bonner 1954, p. 151.

135 Kotansky 1991, p. 107.

136 Many objects excavated from Italian tombs (of as early as the eighth century) are commonly described as jewelry, or an equivalent word, rarely as amulets. Among them are flints, fossilized shark teeth, shells of various species, bear's claws and teeth, boar's tusks, faience figures of Bes, and "Phoenician" glass masks.

137 T. G. H. James, "Ancient Egyptian Seals," in Collon 1997, p. 39; see also Ritner 1993; Andrews 1994, esp. pp. 100–6; and Wilkinson 1994, pp. 82–95.

138 Pinch 1994, p. 105.

139 The word *sympathetic* is used in the sense of sympathetic magic.

140 Pinch 1994, p. 105.

141 Golden tears of amber might have been thought to be everlasting tears of mourning.

142 Dickie 2001, passim.

143 Kotansky 1991; Dickie 2001, p. 93, nn. 54–56.

144 Dickie 2001, p. 93.

145 V. Dasen, "Pour une anthropologie de la naissance et de la petite enfance": http://perso.unifr.ch/veronique.dasen/naissance/naissance.htm (accessed November 27, 2009) surveys the amulets and spells of protection for the pregnant woman, the fetus, parturition, and the newborn. G. Bellucci, *Catalogue descriptif d'une collection d'amulettes italiennes, envoyée à l'Exposition Universelle de Paris, 1889* (Perugia, 1889; repr., 1980), and G. Bellucci, *Il feticismo primitivo in Italia, e le sue*

forme di adattamento, 2nd ed. (Perugia, 1919) show the long duration of charms and amulets in Italy.

146 Magical stones, which protect pregnant women, are listed in most ancient lapidaries.

147 Juvenal, *Satires* 5.163–65, calls the *bulla* the *Etruscum aurum* and some Roman writers (Pliny, *Natural History* 3.4; Festus, *De Significatione Verborum* 26.25; Plutarch, *Vita Romulus* 25) refer to the *bulla* as a specifically Etruscan ornament. *Invidia* is one of the words used to describe the dangers amulets were intended to prevent or act against. The same word (*invidia*) was used in nineteenth-century Italy for the same purposes, as revealed in Bellucci 1889 and Bellucci 1919 (note 145 above).

148 G. Bordenache Battaglia with A. Emiliozzi, *Le ciste prenestine* (Rome, 1990), vol. 1, pp. 181–82, n. 59.

149 Florence, Museo Archeologico Nazionale, no. 4026.

150. Many examples of *bulla*-wearers (including divinities and demons) are found on Etruscan mirrors.

151 The extraordinary series of fourth-century terracotta votive figures from Lavinio are richly ornamented with figural bullae of various forms.

152 Metropolitan Museum of Art 09.221.16, Rogers Fund, 1909.

153 *Bulla*-shaped amber pendants (the commonest form of pendant) are documented in the seventh-century Foundation Deposit at Ephesus and in women's graves in Etruria and South Italy from the eighth century onward.

154 See note 70 above.

155 Amber might have been especially effective in magically attracting the sun, due to its inherent magnetic property and because of amber's "sympathetic" brilliance and color.

156 See D. Pingree, "Some of the Sources of the Ghāyat al-hakīm," *Journal of the Warburg and Courtauld Institutes* 43 (1980):1–5, p. 3. Plantzos 1999, p. 110, notes that "the ability of a lens—*hyalos*—to attract the rays of the sun (Aristophanes, *Clouds* 760–75)" was common knowledge.

157 Kotansky 1991, p. 108.

158 Plato, *Republic* 426 b1–2.

159 Amulets of clay, stone, ivory, and bone and other materials are among the earliest surviving sculpted objects from Italy.

160 Melfi, Museo Archeologico Nazionale del Melfese "Massimo Pallottino" 118680 and 118681 (the female heads) and 118678–79 (the satyr heads) from Tomb

48, Ripacandida: Bottini 1987, pp. 9–12, figs. 13–15, pl. III.

161 Bottini 1990, p. 65; and Bottini 1987, p. 10, n. 39.

162 See note 150 above for the mirror. On Neo-Assyrian seals, the goddess carrying the chaplet is sometimes Ishtar (Inana): Black and Green 1992, pp. 51–52. For the Sumerian material, see, for example, H. Pittman in *Treasures from the Royal Tombs of Ur*, exh. cat., ed. R. L. Zettler and L. Horne (Philadelphia, 1998), pp. 95–96, no. 33.

163 See note 145 above.

164 Goff 1963, pp. 162–211.

165 For a recent discussion of *crepundia* and Roman amber, see M. Lista, "L'ambra dei Romani in Plinio: dal moralismo alla *devotio*," in *Ambre* 2007, pp. 254–59.

166 Potenza, Museo Nazionale Archeologico 96684 (satyr) and 96685 (Herakles, identified in all publications as "maenad"), from Tomb 106, Braida di Serra di Vaglio: *Magie d' ambra* 2005, ill. p. 117; Bottini and Setari 2003, p. 66, fig. 37.

167 Melfi, Museo Archeologico Nazionale del Melfese "Massimo Pallottino" 51436–40, from Tomb 48, Melfi-Pisciolo, second half of the fifth century. Inv. 51436 even has bores in the cheek and the chin.

168 Eos and Kephalos, Matera, Museo Nazionale "Domenico Ridola" 169680, from Tricarico-Serra del Cedro, Tomb 60, middle of the fourth century: *Magie d'ambra* 2005, ill. p. 128; Bottini and Setari 1998, p. 630.

169 For the amber ram's head from Adria, see *Due Donne* 1993. For the Bolognese (Certosa) material, see recent publication by L. Malnati, "L'ambra in Emilia Romagna durante l'età del Ferro: I luoghi della redistribuzione e della produzione," in *Ambre* 2007, esp. pp. 122–29 and 152–59.

170 The female head from Tomb 90 at Latronico-Colle dei Greci is Policoro, Museo Nazionale, 216349: *Ambre* 2007, p. 239. E. Brizio, "Verucchio, Scoperta di sepolcri tipo Villanova," *NSc* 10 (1898): 373, reported that an amber ring from Tomb 11 at Verucchio was repaired in antiquity with "sewing stitches."

171 Amber pendants are not alone in showing signs of use wear—from touching, rubbing, kissing, or other kinds of abrasion as the objects came into contact with the body or clothing. Ritual washing may also have been a cause of the uneven wear.

172 Some classes of amulet wearers deserving closer study include the Laconian acrobats and dancers; babies and toddlers; Cypriot "temple boys"; and certain female divinities.

173 For examples of these two gods adorned with pendants, see L. Bonfante, "Fufluns Pacha: The Etruscan Dionysus," in *Masks of Dionysus*, ed. T. H. Carpenter and C. A. Faraone (Ithaca, NY, 1993), pp. 224–31, figs. 21, 24. The Naples mirror is Museo Archeologico Nazionale 5568, *ES* 82; the Berlin mirror is Antikenmuseum Fr. 36, *ES* 83.

174 For the Tomb of Hunting and Fishing at Tarquinia, see most recently S. Steingräber, *Abundance of Life: Etruscan Wall Painting from the Geometric Period to the Hellenistic Period*, trans. R. Stockman (Los Angeles, 2006); on p. 95 he notes the importance of Dionysian elements in the tombs. Haynes 2001, p. 229, interprets the tomb as Dionysian; compare E. Simon, "Apollo in Etruria," *Annali delle Fondazione per il Museo "Claudio Faina"* 5 (1998): 119-43, where she reiterates her belief that the laurel signifies it as the grove of Apollo.

175 S. Hood, *The Arts in Prehistoric Greece* (London, 1978); E. M. Konstantinidi, *Jewellery Revealed in the Burial Contexts of the Greek Bronze Age*, BAR S912 (Oxford, 2001), pp. 60–62.

176 Hughes-Brock 1985, p. 259.

177 Hughes-Brock 1993, p. 221, and Hughes-Brock 1985, p. 259. Undisturbed burials of both women and men show that burials could contain a single bead.

178 For Qatna, see recent discussion by A. J. Mukherjee et al., "The Qatna Lion: Scientific Confirmation of Baltic Amber in Late Bronze Age Syria," *Antiquity* 82 (2008): 49–59.

179 For amber in Egypt, see note 98 above.

180 Andrews 1994, p. 50.

181 Palavestra and Krstić 2006, p. 23.

182 For Frattesina see Negroni Catacchio 1972.

183 S. Bianco in *Magie d' ambra* 2005, pp. 94–96, ill. p. 99.

184 This is theorized on the basis of a small percentage of excavations or published accounts; the number of unpublished graves and deposits with amber objects, the amount of pre-Roman amber in non-source-country museums and collections (from old or unreported finds and uncontrolled excavations) is unfortunately very high. The exceptions are criti-cal (such as the male Tomb 43 at Melfi-Pisciolo). Gender blurring may also be at issue.

185 Orientalizing Greek and Etruscan images of nonhuman primates are generically referred to as monkeys in the literature. They may represent the long-tailed monkey (*Cercopithecus*), the green monkey, or vervet (*Cercopithecus aethiops*) and baboons, especially the hamadryas baboon (*Papio hamadryas*). The prototypes of the eighth–seventh century amber pendants from Italy (Etruscan, Latin, Faliscan, Picene) are Egyptian in invention, but they may also have derived from Phoenician examples and be related to northern Mesopota-mian, Syrian (north and west Syria), Old Babylo-nian, and Anatolian types and symbolism.

186 For Italian finds of eighth- and seventh-century date, Waarsenburg 1995 is the most complete compendium of objects and earlier bibl., including Massaro 1943.

187 On the Orientalizing phenomenon in Italy, see D. Ridgway, "The Orientalizing Phenomenon in Cam-pania: Sources and Manifestations," in Prayon and Röllig 2000, pp. 233-44, which takes the phenom-enon far beyond Campania.

188 Poggio alla Guardia Necropolis, Tomb 7. Haynes 2001, p. 15, cites the burial as indicating early con-nections with the Near East.

189 Waarsenburg 1995, p. 428. The birds are waterfowl, often ducks, represented as if afloat. See S. Bianco (with bibl.) in *Magie d' ambra* 2005, and Franchi Dell'Orto 1999.

190 For a recent consideration of the pair of tombs, see J. B. Connelly, *Portrait of a Priestess: Women and Ritual in Ancient Greece* (Princeton, 2007), p. 224.

191 A. Bammer, "Kosmologische Aspekte der Artemis-ionfunde," in *Der Kosmos der Artemis von Ephesos*, ed. U. Muss, *Sonderschriften des Österreichischen Archäologischen Instituts* 37 (Vienna, 2001), pp. 11–26 (with earlier bibl.).

192 Also mentioned by Mastrocinque 1991, p. 68.

193 This is noted by Waarsenburg 1995 and Mastro-cinque 1991, p. 78.

194 Verucchio (Rimini), Lippi Necropolis, Tomb 27, inv. 11392: *Principi etruschi*, p. 295, no. 395 (P. von Eles); *Dono delle Eliadi* 1994, p. 161, n. 553, pl. LXI.

195 Human nudity and the partially clothed (where the primary and secondary sex characteristics are

exposed) made for potent signs of sexuality. The gestures may be read as they were in Egypt, as the recording of the most characteristic movement within a sequence of movements.

196 Florence, Museo Archeologico Nazionale 7815.

197 This fish pendant is close to the Egyptian *Lates* amulet type, an emblem of the goddess Neith, one of the four great protectresses of the dead.

198 Haynes 2001, p. 100, queries the identity of the figure between the legs of the seated woman—is it a child or a monkey? It must represent a birthing scene, the throne a birthing chair, the head that of an infant human. See also Waarsenburg 1995, p. 429.

199 Bes, who protected the household, women in childbirth, and their offspring, was closely associated with Hathor, as was the related dwarf god Pataikos-Ptah. As prescribed in magical spells, Patakoi could be worn around the neck as helpers during delivery. Pataikoi are often discovered in burials, where they had a strong afterlife symbolism.

200 On cowries, cowroids, and cowrie-shell imitations in Egypt, see Pinch 1994, p. 107; Andrews 1994, p. 42; and R. E. Freed in *The Quest for Immortality: Treasures of Ancient Egypt*, exh. cat., eds. E. Hornung and B. Bryan (Washington, DC, 2002), p. 102, no. 17.

201 For the find, see the exhaustive treatment in Waarsenburg 1995 and Waarsenburg 1992/93.

202 Waarsenburg 1995, pp. 410–11, nn. 1058–64. Still in early twentieth-century Italy, Neolithic flints are recorded as important amulets for protection against lightning, and to protect people, animals, houses, and land against natural disasters, as G. Bellucci (note 145 above) shows. Was the flint a special amulet, or the property of an interpreter of lightning?

203 The most frequent form of demons is that of a hybrid or monster.

204 See Waarsenburg 1995, p. 430, on the unworked pieces in the Archaic votive deposit. See note 121 above for reference to amber and resins in a tomb at Cerveteri.

205 Ancona, Museo Archeologico Nazionale 1154 (from Tomb 83, Belmonte Piceno): Rocco 1999, pp. 82–85, nos. 135–36, pls. 44–45.

206 C. Rolley, "Sculpture in Magna Graecia," in *Western Greeks* 1996, p. 389.

207 Originally valued primarily as a hunter and, as such, the indispensable companion of gods and particularly of Artemis, the dog eventually assumed the role of guardian and companion and obtained apotropaic powers.

208 British Museum 43: Strong 1966, pp. 66–67, no. 43, pl. xix.

209 Warden 1994. The draped female figures of the Philadelphia group may represent the same type as the female figures of a group in the Getty (see online catalogue nos. 1–4). On the importance of music making in danger aversion, especially in birthing and early childhood, see Bulté 1991. On the child-killing demons, see Johnston 1995, pp. 361–87. The bent-under feet may have magical significance.

210 See F. G. Lo Porto, "Ceramica arcaica dalla Necropoli di Taranto," *Annuario della Scuola Archeologica di Atene e delle Missioni italiane in Oriente* 21-22 (1959/60): 213, n. 7, fig. 183d. The Tomb 116 (Acclavio Str.) is dated to 560–550.

211 D. Schmandt-Besserat, "Animal Symbols at 'Ain Ghazal," *Expedition* 39, no. 1 (1997): 52, quoting D. Kertzer, *Ritual, Politics and Power* (New Haven, 1988), p. 12.

212 J. Elsner, *Roman Eyes: Visuality and Subjectivity in Art and Text* (Princeton, 2007), p. 44.

213 For the amber *kouros* in London (British Museum 41): Strong 1966, pp. 65–66, no. 41, pl. XIX. The *kouros* in the Louvre is unpublished. A comparable amber *kouros* from Arezzo is now lost.

214 For the Novi Pazar material, see Palavestra and Krstić 2006 and Palavestra 2003. Palavestra considers the ambers' style to point to production centers in South Italy. While some works can be linked to ambers from South Italy, the burial seemingly represents the work of many different artisans, traditions, and object types as well as drawing on a variety of sources for subject, style, and type. The ambers of a grave context excavated in 1896 at Sala Consilina (the finds are now in the Petit Palais, Paris) are still not fully published. For Tomb 102 at Braida di Vaglio, see note 272 below.

215 Satyrs in action include the London *Vintaging Satyr* (British Museum 36): Strong 1966, pp. 62–63, no 36, pl. xiv.

216 Most of the bird-woman composite creatures of Orientalizing–Archaic period art are extant in

amber. That the sirens ranged along the coast of Italy, and that Parthenope was traditionally buried at Naples, may provide some explanation for the impressive number of amber sirens from South Italian finds of the sixth-fourth century, some from Campania. Essential was the siren's association with transport to the afterlife and with the underworld and the task of the spiritual nourishment of the dead. An amber in the form of a siren (they had watery origins as daughters of either Achelous, the river god, or of Phorkys and Ceto, the sea divinities) would reiterate watery amber, which was believed to originate in, be hardened by, or be borne by ocean, sea, rivers, or stream.

217 The amber pendant is from the (female?) Tomb 9, Rutigliano-Purgatorio necropolis.

218 The amber of Herakles slaying the Nemean lion (Paris, Bibliothèque nationale, Cabinet des Médailles Fröhner 1146) represents the slaying on the main side of the pendant and a coiled bearded snake on the secondary side, although the figures wrap around the lump: D'Ercole 2008, pp. 52–61; figs. I–II; and La Genière 1967, p. 302, figs. 7–8. The Achilles from the "Tomb of Amber" at Ruvo di Puglia (Naples, Museo Archeologico Nazionale 113643) was found with at least six other figured ambers, including an equine head and three female heads: *Ambre* 2007, pp. 246–47, ill. 280). Martial subjects have a long history as protective objects, beginning in the third millennium and continuing through to the present. In Rome, martial subjects in red-colored stones were especially popular since red is the color of blood and life.

219 On the large and animated eye, see Steiner 2001, pp. 171–81; Faraone 1992, pp. 45, 58–59, 119; and Erhart 1979. On the startling eyes of Mesopotamia, see Winter 2000.

220 Archaic Etruscan gemstones are a case in point.

221 One example is Tomb 955 from Lavello-Casino (Melfi, Museo Archeologico Nazionale "Massimo Pallottino"). See for example, *Magie d'ambra* 2005, pp. 82–83.

222 For the Lavello-Casino Tomb 995, see note 221 above. For the Braida di Vaglio Tomb 102, see note 272 below.

223 The chorus of Sophocles' *Antigone* invokes Dionysos "the protector of all Italy." The British Museum *Satyr and Maenad* (Strong 1966, pp.

61–62, no. 35) is perhaps the most complex of the "Orphic" ambers.

224 Garnered from essays by A. M. Nava, S. Bianco, A. Bottini, and M. Tagliente in *The Wine of Dionysos: Banquets of Gods and Men in Basilicata*, exh. cat. (Rome, 2000).

225 *Sophocles: The Plays and Fragments*, trans. R. C. Jebb, Part 3, *Antigone* (Cambridge, 1900), 115s.

226 The literature on Dionysos in Italy is vast. A. Bottini, "Le ambre nella Basilicata settentrionale," in *Ambre* 2007, p. 233, cites the British Museum *Satyr and Maenad* pendant (Strong 1966, no. 35) as another example of the identification of a deceased person with Dionysos.

227 Cole 1993, pp. 277–79.

228 E. R. Dodds, *The Bacchae of Euripides* (Oxford, 1944), p. xii.

229 This author was among the first to suggest the continuity of Dionysian subjects in Italian amber objects, from the Orientalizing through Late Antiquity. See also Mastrocinque 1991 and D'Ercole 1995, n. 18.

230 Herakles' seminal role in amuletic magic is partly explained by his ability, even as a baby, to overcome dangerous animals and monsters and to have conquered Death. Herakles' survival of Chiron's fatal poison might have made him a "wounded healer" (*similia similibus curantur*). His role in spring cults and his sanative aspects relate to his successful cleansing with water of the Augean stables and other exploits. In private worship especially, Herakles was commonly appealed to as a warder-off of evils and victor over them.

231 As S. J. Schwarz, *LIMC* 5 (1990), pp. 196–253; and *LIMC* suppl. 1 (2009), pp. 244–64, documents, there are few places in Italy where Herakles/Hercle is not evident and not honored.

232 S. Sande, "Famous Persons as Bringers of Good Luck" in Jordan et al. 1999, p. 233.

233 Bonner 1950, passim.

234 Alexander of Tralles 2.377 (Bonner 1950, p. 63, nn. 43–44). Bonner, p. 64, cites other relevant medico-magical prescriptions.

235 R. Papi, "Materiali archeologici da Villalfonsina (Chieti)," *Archeologia Classica* 31 (1979): pp. 18–95.

236 Pontrandolfo Greco 1977.

237 The Timmari (Basilicata) necklace was found in Tomb 1; see Losi et al. 1993, n. 20.

238 See Mastrocinque 1991, p. 143, n. 477.

239 Dickie 2001.

240 The ivory-working techniques in the Aegean and Near East during the second–first millennia are relatively well understood from the tool marks on ancient ivory (and osseous) objects and from excavated "workshop material." For the Orientalizing period in Italy, evidence for the working of various hard materials is found together in the same atelier from seventh-century Poggio Civitate.

241 That craftsmen worked in a variety of materials is suggested by a range of "multimedia" furnishings and other kinds of objects from very early times throughout the Mediterranean and the ancient Near East. Warden 1994 makes an excellent case for amber being worked by ivory carvers, as does Waarsenburg 1995, n. 1121. A. Russo, "L'ambra nelle terre dei Dauni e dei Peuketiantes," in *Magie d'ambra* 2005 and Rocco 1999 discuss the rapport among amber, ivory, and bone carving.

242 Massaro 1943, pp. 36ff., no. 27/a, recorded that the bored concentric eyes of the female pendants from the Circolo dei Monili preserved traces of a silver inlay (reference from Waarsenburg 1995, p. 429, n. 1123).

243 See A. Hermary, "Un petit kouros en bois de Marseille (Fouilles de la Bourse)," *RA* 99 (1997): 227–41, n. 14, fig. 5 a–d (inv. H 34), who dates it "third-quarter to end of the seventh century."

244 Delphi Museum 10413–14, circa 550. See Lapatin 2001, no. 33, for illustrations and bibl.

245 Forming holes from both ends toward the center prevents "blowout"— a technique already in evidence in earliest bead and pendant making.

246 Theophilus, Book 95 (*The Various Arts*, trans. C. R. Dodwell [London, 1961], pp. 168–69). G. Kornbluth, *Engraved Gems of the Carolingian Empire* (University Park, PA, 1995), pp. 9–10, provided the useful model of using Theophilus.

247 The sketching might have been done in a manner similar to that recommended by Theophilus, Book 98 (note 246 above, p. 166). Theophilus advises scoring "the outlines with a sharp tracer so that they are quite clear."

248 Pliny, *Natural History* 37.15 and 37.65.

249 Trieste, Civico Museo di Storia ed Arte 9795. Pendant-pectoral from Santa Lucia di Tolmino/Most na Soči, tomb 3070, end of the seventh–beginning of the sixth century B.C.: *Ambre* 2007, p. 120, fig. III.8.

250 For the most recent discussion of the composite jewelry, see Palavestra and Krstić 2006, pp. 94–115.

251 Kotansky 1991, pp. 107–8.

252 Theophilus, Book 95 (note 246 above), p. 169.

253 Steiner 2001, p. 101. On the ambrosial fragrance of the gods, see also Lapatin 2001, p. 55; N. J. Richardson, *The Homeric Hymn to Demeter* (Oxford, 1974), p. 252; and Shelmerdine 1995 (note 67 above).

254 T. Follett, "Amber in Goldworking," *Archaeology* 38, no. 2 (1985): 64–65; but compare G. Nestler and E. Formigli, *Granulazione Etrusca: Un antica tecnica orafa* (Siena, 1994).

255 Johnston 1995, p. 363. The appearance of shape shifting could be conceived as an attestation of the artisan's skill in making what were perhaps to be considered *daidala*.

256 Because of this, each amber object is unique. Figures contorted, splayed, or wrapped around planes are seen in ancient Near Eastern animal representations as early as the fourth millennium, and some Mycenaean ivories and Middle Assyrian alabaster vessels suggest that such figure manipulation was well-established much earlier.

257 Perhaps only Chinese amber carvers and Japanese inro and netsuke makers have exploited the material and figural form to the same degree.

258 Tumulus II of Melone del Sodo at Cortona: P. Zamarchi Grassi, "Il tumulo II del Sodi di Cortona (Arezzo), in *Principi etruschi* 2000, pp. 140–42, no. 109.

259 On binding in magic, see J. Gager, *Curse Tablets and Binding Spells from the Ancient World* (New York and Oxford, 1992), Faraone 1992, and Faraone 1991.

260 The insertion of materials into an amulet or "talismanic statue" is not uncommon in ritual and magical practice.

261 Strong 1966 and others thought the plugs might be for coloristic effects. It is more likely that the plugs have more rapidly darkened.

262 There are numerous pendants with large secondary holes in other collections and on the art market.

263 Ridgway 2000 (note 187 above), p. 236.

264 Ridgway 2000 (note 187 above), p. 236.

265 See M. Hegmon, "Technology, Style, and Social Practices: Archaeological Approaches," in *The*

Archaeology of Social Boundaries, ed. M. T. Stark (Washington and London, 1998), pp. 264–79.

266 For sites of manufacture, see La Genière 1961, pp. 87–88; Strong 1966; Bottini 1987; Mastrocinque 1991; D'Ercole 1995; Bottini and Setari 2003; Russo 2005 (note 241 above); Palavestra and Krstić 2006; and D'Ercole 2008.

267 D'Ercole 2008, pp. 52–69, convincingly argues for an Ionian working in Etruria for the Heracles and the Nemean Lion group of circa 530–500 b.c. in Paris (Bibliothèque nationale, Cabinet de Médailles Fröhner 1146).

268 This has also been done by a number of University of Milan students, noted by Negroni Catacchio 1999.

269 Bottini 1987, p. 12, has suggested several reasons for this but emphasizes the existence of a clientele capable of appreciating and acquiring luxury articles. Might it have been a temple, cult, shrine, or healer at Canosa or Armento which was the draw?

270 On Armento as a center, see most recently, A. Bottini, "Le ambre nella Basilicata settentrionale," in *Ambre* 2007, pp. 232–33, and Russo 2005 (note 241 above).

271 Bottini and Setari 2003; A. Bottini (pp. 541–48) and E. Setari (p. 644) in *Western Greeks* 1996; Bottini and Setari 1995a, 1995b, and 1998; and E. Pica in *Treasures* 1998, pp. 224–25, pls. 32, 33. See also E. Greco, *Archeologia della Magna Grecia* (Rome, 1992).

272 Bottini and Setari 2003.

273 Bottini 1987 discusses the figured ambers of two "princely" tombs at Melfi-Pisciolo, as being older than their (second half of the fifth century) contexts.

274 The "seer, or a healer of illnesses, or a carpenter who works on wood, or even an inspired singer" named by Eumaios (*Odyssey* 17.381–87) are four kinds of high-ranking strangers, any one of which (theoretically) could have been involved in aspects of amulet construction. The translation is from G. Nagy, *The Best of the Achaeans. Concepts of the Hero in Archaic Greek Poetry*, rev. ed. (Baltimore 1997), pp. 233–34.

275 The Eretum pendants are from Tomb XIII: P. Santoro, "Sequenza culturale della necropoli di Colle del Forno in Sabina," *Studi Etruschi* 51 (1985): 13–37; Losi et al. 1993, p. 203.

276 D. Frankfurter, "Narrating Power: The Theory and Practice of the Magical *Historiola* in Ritual Spells," in Meyer and Mirecki 1995, p. 3.

277 D'Ercole 1995.

278 Strong 1966, pp. 67–71, no. 44–43.

Bibliography

Bibliographic Abbreviations

AJA
 American Journal of Archaeology
AJP
 American Journal of Philology
BAR
 British Archaeological Reports
CVA
 Corpus vasorum antiquorum
ES
 Gerhard, E., G. Koerte, and A. Klugman. *Etruskische Spiegel* I-V. Berlin 1840–97.
LIMC
 Lexicon iconographicum mythologiae classicae. Zurich and Munich, 1974–.
NSc
 Notizie degli scavi di antichità
RA
 Revue archéologique
RE
 Pauly-Wissowa. *Real-Encyclopädie der klassischen Altertumswissenschaft*, 1893–.
StEtr
 Studi etruschi
ThesCRA
 Thesaurus Cultus et Rituum Antiquorum

Frequently Cited Sources

A

Albizzati, C. "Un ambra scolpita d'arte ionica nella raccolta Morgan." *Rassegna d'arte antica e moderna* 10 (1919): 183–200.

Ambre: Trasparenze dall'antico. Exh. cat. Naples, Museo Archeologico Nazionale, 2007.

Anderson, K. B., and J. C. Crelling, eds. *Amber, Resinite and Fossil Resins*. Washington, DC, 1995.

Andrews, C. *Amulets of Ancient Egypt*. Austin, Texas, 1994.

Art of the Classical World in the Metropolitan Museum of Art: Greece – Cyprus – Etruria – Rome. A.Picón et al. New York, 2007.

B

Barfod, J. "Bernstein in Volksglauben und Volksmedizin." In *Bernstein—Tränen der Götter* 1996, p. 453 ff.

Barfod, J. *Bernstein*. Husum, Germany, 2005.

Barfod, J., F. Jacobs, and S. Ritzkowski. *Bernstein: Schätze in Niedersachsen*. Seelze, 1989.

Becatti, G. *Oreficerie antiche dalle Minoiche alle Barbariche*. Rome, 1955.

Beck, C. W., I. B. Loze, and J. M. Todd, eds. *Amber in Archaeology: Proceedings of the Fourth International Conference on Amber in Archaeology, Talsi, 2001*. Riga, 2003.

Beck, C. W., J. Bouzek, D. Dreslerova, eds. *Amber in Archaeology: Proceedings of the Second International Conference on Amber in Archaeology, Liblice 1990*. Prague, 1993.

Beck, C. W., and S. Shennan. *Amber in Prehistoric Britain*. Oxford, 1991.

Bernstein—Tränen der Götter. Eds. Ganzelewski, M., and R. Slotta. Exh. cat. Bochum, 1996.

Beyond Babylon: Art, Trade, and Diplomacy in the Second Millennium B.C. Exh. cat. New York, 2008.

Black, J., and A. Green. *Gods, Demons and Symbols of Ancient Mesopotamia: An Illustrated Dictionary*. Austin, Texas, 1992.

Bonner, C. *Studies in Magical Amulets, Chiefly Graeco-Egyptian.* Ann Arbor, 1950.

Bonner, C. "A Miscellany of Engraved Stones." *Hesperia* 23, no. 2 (1954): 138–57.

Bottini, A. "Ambre a protome umana dal Melfese." *Bollettino d'arte* 72, no. 41 (1987): 1–16.

Bottini, A. "Le ambre intagliate a figura umana del Museo archeologico nazionale di Melfi." *Archaelogia Warszawa.* 41 (1990): 57–66.

Bottini, A. "La Tomba 955 di Lavello-Forentum." In *Due Donne* 1993, pp. 63-69.

Bottini, A., and E. Setari. "Basileis? I più recenti rinvenimenti a Braida di Serra di Vaglio: Risultati, prospettive e problemi." *Bollettino di Archeologia* 16–18 (1992 [Rome, 1995 (a)]): 1–34.

Bottini, A., and E. Setari. *Basileis: Antichi re in Basilicata.* Rome, 1995 (b).

Bottini, A., and E. Setari. "L'artigianato arcaico dell'ambra alla luce dei più recenti rinvenimenti in Basilicata." In Negroni Catacchio and Beck 1998, pp. 469–77.

Bottini, A., and E. Setari, with an appendix by M. Torelli. *La necropoli italica di Braida di Vaglio in Basilicata: Materiali dallo scavo del 1994. Monumenti antichi* 60, serie miscellanea 7. Rome, 2003.

Bouzek, J. "The Shifts of the Amber Route." In Beck and Bouzek 1993, pp. 141–46.

Bulté, J. *Talismans égyptiens d'heureuse maternité: "Faïence" bleu-vert à pois foncés.* Paris, 1991.

C

Carter, J.B., and S. P. Morris, eds. *The Ages of Homer: A Tribute to Emily Townsend Vermeule.* Austin, Texas, 1995.

Caubet, A., ed. *Cornaline et pierres précieuses: La Méditerranée, de l'Antiquité à l'Islam; Actes du colloque organisé au Musée du Louvre, 24–25 novembre 1995.* Paris, 1999.

Causey, F. "Two Amber Pendants in Malibu: East Greek Craftsmanship?" In Beck and Bouzek 1993, pp. 212–18.

Causey, F. "An Amber Pendant in the Form of a Ship with Sailors." In Clark and Gaunt 2002, pp. 63–67, pl. 11.

Causey, F., with J. Shepherd. "Amber." In *Colour in the ancient Mediterranean world: Papers from the international conference "Colour in Antiquity" held September 2001 at Edinburgh University,* ed. L. Cleland et al., pp. 70–72. BAR International Series 1267. Oxford, 2004.

Causey, F. "Anbar, Amber, Bernstein, Jantar, Karabe." In *Bernstein, Sigmar Polke, Amber.* Exh. cat. New York, 2007.

Causey, F. "A Kore in Amber." In *Archaic Greek Culture: History, Archaeology, Art and Museology; Proceedings of the International Round-Table Conference June 2005, St. Petersburg, Russia,* ed. S. Solovyov, pp. 6–9. BAR Series S2061. Oxford, 2010.

Clark, J., and J. Gaunt, with B. Gilman. *Essays in Honor of Dietrich von Bothmer.* Amsterdam, 2002.

Cole, S. G. "Voices from beyond the Grave: Dionysus and the Dead." In *Masks of Dionysus,* eds. T. H. Carpenter and C. A. Faraone, pp. 276–96. Ithaca and London, 1993.

Collon, D., ed. *7000 Years of Seals.* London, 1997.

D

D'Ercole, C.-M. "Observations sur quelques ambres sculptés archaïques d'Italie méridionale." *Revue Archéologique* 2 (1995): 265–90.

D'Ercole, C.-M. *Ambres gravés du département des Monnaies, Médailles et Antiques.* Paris, 2008.

De Puma, R., and J. P. Small, eds. *Murlo and the Etruscans: Art and Society in Ancient Etruria.* Madison, Wis., 1994.

Dickie, M. *Magic and Magicians in the Greco-Roman World.* London and New York, 2001.

Dono delle Eliadi, Il: Ambre e oreficerie dei principi etruschi di Verucchio. Exh. cat. Rimini, 1994.

Dopp, S. "Die Tränen von Phaethons Schwestern wurden zu Bernstein: Der Phaethon-Mythos in Ovids 'Metamorphosen.'" In *Bernstein—Tränen der Götter* 1996, pp. 1–10.

Due Donne dell' Italia antica: Corredi da Spina e Forentum. Ed. Baldoni, D. Exh. cat. Padua, 1993.

E

Eichholz, D. E. trans. Pliny. *Natural History, Books 36–37.* Loeb Classical Library 419. Cambridge, 1962.

F

Faraone, C. A. "The Agonistic Context of Early Greek Binding Spells." In Faraone and Obbink 1991, pp. 3–32.

Faraone, C. A. *Talismans and Trojan Horses: Guardian Statues in Ancient Greek Myth and Ritual.* New York, 1992.

Faraone, C. A., and D. Obbink. *Magika Hiera: Ancient Greek Magic and Religion.* New York and Oxford, 1991.

Foster, K. Pollinger. "Dionysos and Vesuvius in the Villa of the Mysteries." *Antike Kunst* 44 (2001): 37–54.

Franchi dell'Orto, L. "Le 'anatrelle': sopravvivenza di una simbologia religioso dell' età del bronzo europea." In *Piceni* 1999, pp. 91–92.

G

Gage, J. *Color and Culture: Practice and Meaning from Antiquity to Abstraction.* Boston, Toronto, and London, 1993.

Geerlings, W. "Die Tränen der Schwestern des Phaethon—Bernstein im Altertum." In *Bernstein— Tränen der Götter* 1996, pp. 395–400.

Gaslain, C. "Dalle rive del mare alle tombe principesche: la circolazione dell'ambra nel bacino del Mediterraneo nell'età del Bronzo e nell'età del ferro." In *Magie d'ambra* 2005, pp. 55–70.

Goff, B. L. *Symbols of Prehistoric Mesopotamia.* New Haven and London, 1963.

Grimaldi, D. A. *Amber: Window to the Past.* New York, 1996.

H

Haynes, S. *Etruscan Civilization: A Cultural History.* Los Angeles, 2000.

Hughes-Brock, H. "Amber and the Mycenaeans." *Journal of Baltic Studies* 16, no. 3 (1985): 257–67.

Hughes-Brock, H. "Amber in the Aegean in the Late Bronze Age: Some Problems and Perspectives." In Beck and Bouzek 1993, pp. 223–24.

Huld, M. E. "Greek Amber." In *From the Realm of the Ancestors: An Anthology in Honor of Marija Gimbutas,* ed. J. Marler (Manchester, CT, 1997), pp. 135–39.

J

J. Paul Getty Museum, The, Handbook of the Antiquities Collection. Los Angeles, 2002.

J. Paul Getty Museum, The, Handbook of the Antiquities Collection. Los Angeles, 2010.

Jannot, J. R. *Religion in Ancient Etruria.* Trans. J. Whitehead. Madison, Wis., 2005.

Johnston, S. I. "Defining the Dreadful: Remarks on the Greek Child-Killing Demon." In Meyer and Mirecki 1995, pp. 361–87.

Jordan, D. R., E. Thomassen, and H. Montgomery, eds. *The World of Ancient Magic: Papers from the First International Samson Eitrem Seminar at the Norwegian Institute at Athens 4-8 May, 1997.* Bergen, 1999.

K

Keesling, C. M. *The Votive Statues of the Athenian Acropolis.* Cambridge, 2003.

Kotansky, R. "Incantations and Prayers for Salvation on Inscribed Greek Amulets." In Faraone and Obbink 1991, pp. 107–37.

Kredel, F. "Ein archaisches Schmuckstück aus Bernstein." *Jahrbuch des Deutschen Archäologischen Instituts* 38–39 (1923–24): 169–80.

L

La Genière, J. de. "Ambre intagliate del Museo di Salerno." *Apollo* 1 (1961): 73–88.

La Genière, J. de. "À propos du catalogue des ambres sculptés du British Museum." *Revue Archéologique* (1967): 297–304.

Langenheim, J. H. *Plant Resins: Chemistry, Evolution, Ecology, and Ethnobotany.* Portland, Oregon, 2003.

Lapatin, K. D. S. *Chryselephantine Statuary in the Ancient Mediterranean World.* New York, 2001.

Losi, M., B. Raposso, and G. Ruggiero. "The Production of Amber Female Heads in Pre-Roman Italy." In Beck and Bouzek 1993, pp. 203–11, pls. 11–13.

M

Magie d'ambra: Amuleti et gioielli della Basilicata antica. Exh. cat. Potenza, 2005.

Marconi, P. "La cultura orientalizzante nel Piceno." *Monumenti antichi* 35 (1933): cols. 265–454.

Massaro, D. "Le ambre de Vetulonia." *StEtr* 18 (1943): 31–46.

Mastrocinque, A. *L'ambra e l'Eridano: Studi sulla letteratura e sul commercio dell'ambra in età preromana.* Este, 1991.

Meyer, M,. and P. Mirecki, eds. *Ancient Magic and Ritual Power.* Leiden, 1995.

Mottahedeh, P. Erhart, *The Development of the Facing Head Motif on Greek Coins and Its Relation to Classical Art.* New York, 1979.

N

Negroni Catacchio, N. "L'ambra: produzione e commerci nell'Italia preromana." In *Italia omnium terrarum parens,* edited by C. Ampolo et al., pp. 659–96. Milan, 1989.

Negroni Catacchio, N. "Alcune ambre figurate preromane di provenienza italiana in collezioni private di New York." In *KOINA: Miscellanea di studi archeologiche in onore di Piero Orlandini,* ed. C. Castoldi, pp. 279–90. Milan, 1999.

Negroni Catacchio, N., and C. W. Beck. "Amber in Archeology." In *Atti de 13. Congresso Unione internazionale delle scienze preistoriche e protostoriche, Forlì, 8-14 settembre, 1996*. Rome, 1998.

Nicholson, P. T., and I. Shaw, eds. *Ancient Egyptian Materials and Technology*. Cambridge, 2000.

P

Palavestra, A. "A Composite Amber Jewelry Set from Novi Pazar." In Beck et. al. 2003, pp. 213–23.

Palavestra, A., and V. Krstić. *The Magic of Amber*. Belgrade, 2006.

Piceni: popolo d'Europa. Colonna, G. ed. Exh. cat. Rome 1999.

Pinch, G. *Magic in Ancient Egypt*. Austin, Texas, 1994.

Plantzos, D. *Hellenistic Engraved Gems*. Oxford, 1999.

Pontrandolfo Greco, A. "Su alcune tombe pestane: Proposte di una lettura." *Mélanges de l'École française de Rome, Antiquité* 89 (1977): 31–98.

Prayon, F., and W. Röllig. *Orient und Etrurien, Zum Phänomen des 'Orientalisierens' im westlichen Mittelmeerraum (10.–6. Jh. v. Chr.): Akten des Kolloquiums Tübingen, 12–13 June 1997*. Pisa, 2000.

Principi etruschi tra Mediterraneo ed Europa. Eds. Bartolini, G., et al. Exh. cat. Bologna, 2000.

R

Rice, P. C. *Amber, the Golden Gem of the Ages*. Bloomington, IN, 2006.

Richter, G. M. A. *Handbook of the Etruscan Collection* [Metropolitan Museum of Art]. New York, 1940.

Riddle, J. M. "Amber and Ambergris in Materia Medica during Antiquity and the Middle Ages." PhD diss., University of North Carolina, Chapel Hill, 1965.

Ritner, R. K. *The Mechanics of Ancient Egyptian Magical Practice*. Chicago, 1993.

Rocco, G. *Avori e ossi dal Piceno*. Rome, 1999.

Ross, A. *Amber: The Natural Time Capsule*. London, 1998.

S

Schwarzenberg, E. "L'ambre: du mythe à l'épigramme." *Revue des études anciennes* 24 (2001): 33–67.

Serpico, M., with a contribution by R. White. "Resins, amber and bitumen." In Nicholson and Shaw 2000, pp. 430–74.

Shennan, S. "Amber and its Value in the British Bronze Age." In Beck and Bouzek 1993, p. 59–66.

Siviero, R. *Jewelry and Amber of Italy: A Collection in the National Museum of Naples*. New York, 1959.

Steiner, D. T. *Images in Mind: Statues in Archaic and Classical Greek Literature and Thought*. Princeton, 2001.

Stewart, A. F. *Art, Desire and the Body in Ancient Greece*. Cambridge, 1997.

Strong, D. E. *Catalogue of the Carved Amber in the Department of the Greek and Roman Antiquities*. London, 1966.

T

Treasures from the South of Italy: Greeks and Indigenous Peoples in Basilicata. Exh. cat. Milan, 1998.

W

Waarsenburg, D. J. "Astarte and Monkey Representations in the Italian Orientalizing Period: The Amber Sculptures from Satricum." In *Akten des Internationalen Kolloquiums "Interactions in the Iron Age: Phoenicians, Greeks and the Indigenous Peoples of the Mediterranean," Amsterdam am 26 und 27 März 1992 = Hamburger Beiträge zur Archäologie* 19/20 (1992/93): 33–71.

Waarsenburg, D. J. *The Northwest Necropolis of Satricum: An Iron Age Cemetery in Latium Vetus*. Amsterdam, 1995.

Warden, G. P. "Amber, Ivory, and the Diffusion of the Orientalizing Style along the Adriatic Coast: Italic Amber in the University Museum (Philadelphia)." In De Puma and Small 1994, pp. 134-43.

Western Greeks, The. Ed. Pugliese Carratelli, G. Exh. cat. Venice, 1996 (published in English as *The Greek World: Art and Civilization in Magna Grecia and Sicily*, New York, 1996).

Wilkinson, R. H. *Symbol and Magic in Egyptian Art*. New York, 1994.

Winter, I. J. "Radiance as an Aesthetic Value in the Art of Mesopotamia (with some Indian Parallels)." In *Art: The Integral Vision; A Volume of Essays in Felicitation of Kapila Vatsyayan*, ed. B. N. Saraswati et al., pp. 123–31. New Delhi, 1994.

Winter, I. J. "The Eyes Have It: Votive Statuary, Gilgamesh's Axe, and Cathected Viewing in the Ancient Near East." In *Visuality Before and Beyond the Renaissance: Seeing as Others Saw*, ed. R. S. Nelson, pp. 22–44. New York, 2000.

Index

on figured amber, in Orientalizing period, 91–94, 140n240

incense burning and, 69, 70, 94, 135n119, 135n127

inclusions and, 44

long-distance trade and, 65, 90, 96, 134n105

manufacturing techniques / tools and, 111, 112–13, 114, 118–19, 140nn240–41

See also Italian excavations

Aristotle, 14, 61

Asinine Head in Profile (fig. 59), 123, *124*

Assyria, 64, 80, 136n162, 140n256

B

Bacchus, head from statue of (fig. 51), *107*

Baltic amber

assorted pieces of (fig. 14), *35*

barnacle-encrusted (fig. 24), *53*

botanical source of, 28

burning piece of (fig. 30), *70*

cone in (fig. 13), *33*

holes in, 84

identification of, in Getty collection, 131n3

location of deposits, 34

mythical origins of amber and, 54

polished piece of (fig. 2), *13*

prevalence of, 11, 14, 34, 37

properties of, 37

in Qatna lion's-head vessel, 90

succinite, explained, 34

two pieces of (fig. 16), *39*

Bestiarius, illustration from (fig. 22), *48*

Boar Pendant (fig. 46), *97*, *100*

brilliance of amber

astrological beliefs and, 79, 136n155

divine or heroic associations with, 45–46, 49–50, 51, 55, 57, 59, 132n53, 133n67

names for amber and, 44, 51

transparency and, 41, 45, 132n44

Britain, 65, 132n36

burials. *See* funerary use of amber

C

Caesarius of Arles, 70–71

Celtic culture, 55, 57, 59, 96

childbirth

amulets for, as ancient tradition, 74–75

amulets for death and, 23

birthing scenes, 93, 138n198

goddesses associated with, 48, 89

inclusions in amber and, 75, 136n146

among occasions requiring protection, 24, 73–74

shell-shaped pendants and, 93–94

See also fertility

China, 37, 64, 69, 132n34, 140n257

Claudian, 59

color of amber

astrological beliefs and, 136n155

Dionysian rituals and, 106

fire or sun associated with, 20, 45, 46, 51, 52, 79, 133n70

hole plugs and, 140n261

lynx-urine myth and, 48

most valued, 38, 50–51, 133n70

oxidation and, 38–39

Pliny on, 45, 51

Cowrie Shell / Hare Pendant (fig. 45), 94, *95*

crater, red-figure (fig. 35), 76, *76*–77

cup, Hove tumulus, *50*

D

Dancing Figure or Head of Satyr (fig. 39), 83, *84*

Dancing Youth (fig. 57), 119, *120*

death. *See* funerary use of amber

Diodorus Siculus, 20, 57

Diogenes Laertius, 132n36

Dionysos, cult of

amulets and, 26, 75, 77

artistic trends in 6th–4th centuries B.C. and, 103, 106, 109, 111, 139n223

Tomb of Hunting and Fishing depictions, 86, 137n174

wine and, 106, 133n74

Dionysos, head from statue of (fig. 51), *107*

Dioscorides, 49

Divinity Holding Hares (fig. 47), 98, *99*

E

earrings (fig. 18), *41*

Egypt

amuletic inscriptions in, 80

astrological beliefs in, 79

Bes, cult of, 93, 94, 133n74, 135n136, 138n199

brilliance, as divine quality in, 132n53

Cleopatra, 61

color associations in, 133n70

duck amulets in, 91–92

funerary amulet use in, 23

incense burning in, 69–70, 135n122

influence of, on figured amber, 119, 126, 129, 137n185

jewelry as predominantly amuletic in, 73

multiple ritual specialists in, 27, 131n20

necklaces as female rite of passage in, 135n128

Orientalizing influence, extent of, 137n187

shell-shaped pendants in, 93–94

as source of raw amber, 37, 46, 48, 52, 54, 105

swan-solar associations in, 59

trade and transport of amber in, 65, 66, 84, 90, 105, 125–26

See also Etruscan culture; Roman Empire

J

jewelry

as catchall archaeological term, 135n136

earliest examples, 13, 27, 131n1

among everyday uses of amber, 11, 59

fake amber in, 65

fibulae of joined or inlaid amber, 63, 91, 96, 111, 113

as gifts or offerings, 15, 24, 79, 135n128

Greek literature / mythology and, 17–18, 26, 45–46, 60, 83

handling and wear of objects, 67, 82–84, 136nn170–71

head-shaped items, 4th century B.C., 110–11

modern use of amber in, 44

in Orientalizing period, 93–94

pendant carving, and shape of raw amber, 119–22

pendant holes and knotting, 84, 117–18, 122–23, 140n245, 140n262

pendants symbolizing deities, 23, 97, 99

precious-metal settings of amber, 41, 132n45

uses and significance of, summarized, 15, 17–18, 20, 28

See also amulets; *and specific jewelry objects*

Juvenal, 51, 63, 66, 134n99, 136n147

K

kouroi, 100, 114, 138n213

L

Leonardo da Vinci, 63

Lion Pendant (fig. 58), 41, 114, *121*, 121–22

Lions, Paired (fig. 5), *18*

Lion's Head Pendant (fig. 44), 86, *88*

Lion's Head Spout or Finial (fig. 60), 127, *128*

Lions' Heads (Addorsed) with Boar in Relief Plaque (fig. 33), *72*, 73, 114

Lion with Bird (fig. 29), *68*

M

magic

dogs' protective powers, 138n207

electromagnetism of amber and, 11, 20, 62, 79, 136n155

among everyday uses of amber, 66

fertility magic, and birth spacing, 131n14

figural contortion and, 122

figured amber's protective powers, 23–24, 26–27, 73, 103 (*see also* amulets)

funerary rituals and, 21, 23–24

handling and wear of objects, 67, 82

heroic figures and, 110

incense burning and, 69, 135n119

Italian amber use as emphasizing, 14

jewelry's functions and, 17

knots and, 118

modern use of amber in, 44, 80, 82

mythical origins of amber and, 58

practitioners of, summarized, 27, 74

shape shifting, 120, 140n255

magnifying property of amber, 38, 132n38

Martial, 51, 61, 63, 66

medicinal use of amber

amulets as both magical and, 18, 20

electromagnetism and, 62

among everyday uses, 11, 59

handling and wear of objects, 82

healers, as amber carvers, 127–28, 129, 130, 141n274

incantations and, 20, 79–80

incense burning and, 69

low-grade amber used in, 37, 119

in modern times, 44

mythical origins of amber and, 58

resin's healing properties and, 75

specific conditions, listed, 20, 70, 110

Medusa, Head of (fig. 31), 71, *71*

mirror with Peleus, Thetis, and Galene (fig. 36), 77, *77*, 80

Morgan Amber, 59–61, *60*

Mummy Portrait of a Woman (fig. 3), *16*

myths about amber

on its magnetism, 94

on its origins, 13–14, 21, 48, 49, 52–55, 57–59, 62, 133n61

on its transparency, 45

N

names for amber, 11, 38, 44–46, 48–49, 51, 132n47, 133n64, 134n116

necklace of amber and gold (fig. 37), *78*

necklaces of amber, and gold ornaments (fig. 6), *19*, 83, 105

Necklace with a Pendant Scarab (fig. 21), *47*

O

Ovid, 55

P

Pausanias, 20–21, 50, 63, 66

Philemon, 49

Phoenicia, 65, 91, 135n136, 137n185

Pindar, 54

plant matter, in amber, 11, 32, 33, 34, 37, 44, 61

Plato, 20, 80

Pliny, the Elder

 on colors of amber, 45, 51

 on engraving tools, 117

 on forgery of amber and gemstones, 62, 63

 on inclusions in amber, 61, 134n94

 on names for amber, 49

 on Nero's display of amber, 66

 on origins of amber, 48, 52–54, 57, 61, 133n61

 on uses of amber, 20, 23, 67, 68, 70, 84

 on wine, 133n74

Plutarch, 106

Q

Quintus Smyrnaeus, 50, 55

R

Ram's Head Pendants (figs. 32 and 42), *72*, 86, *87*, 100

Reclining Couple with an Attendant (fig. 41), 86, *86–87*

religion

 amulets or pendants symbolizing deities, 23, 26–27, 97, 99

 amulet-wearing deities, in art, 84–86

 Aphrodite and Adonis, iconography of, 60

 Apollo, cult of, 49, 52, 54–55, 86, 92

 Artemis, cult of, 26, 48, 58, 92, 96, 133n74, 138n207

 Assyrian iconography, 80, 136n162

 Bes, cult of, 93, 94, 133n74, 135n136, 138n199

 brilliance, as divine quality, 45–46, 49–50, 51, 55, 57, 59, 132n53, 133n67

 demons, 74, 118, 120, 136n150, 138n203

 divine statues, and perfumed oils, 51–52, 118

 foundation deposits in sanctuaries, 89, 92, 135n119, 136n153

 Herakles, cult of, 26, 73, 83, 103, 109–10, 139n218, 139nn230–31

 incense, as divine offerings, 68–69, 135n122, 135n126

 jewelry's functions and, 15, 17, 18

 Neith, cult of, 138n197

 sanctuaries, as centers of commerce / production, 125, 127, 129, 130, 141n269

 See also Dionysos, cult of; funerary use of amber

ring dedicated to Hera (fig. 4), *17*

Roman Empire

 amber trade in, 37, 111

 amuletic inscriptions in, 129

 Augustus' amber statue, 14, 21, 50, 63, 66

 color associations in, 51, 139n218

 color of amber preferred in, 38

 crepundia, 82

 Dionysian figured ambers in, 109

 Forum, amber finds at, 91

 incense burning in, 69–70

 Nero's display of amber, 14, 66

 New Year's gifts in, 71

 wine in, 133n74

 See also Italy; Pliny, the Elder

Russia, 34, 63

S

Satyr, Head of (fig. 39), 83, *84*

Satyr and Maenad (fig. 19), 41, *42*, 99, 119, 122, 123

Satyr Head in Profile (fig. 52), *108*

Satyr Head Pendant with Silver Pin (fig. 54), *112, 113*, 123

Seated Divinity Statuette (fig. 27), *64, 64–65*

Ship with Figures (fig. 9), *25*, 99, 118

Socrates, 20, 80

Sophocles, 57, 106, 139n223

Strabo, 48, 58

Syria, 14, 37, 49, 54, 65, 67, 90, 132n34, 137n185

T

Tacitus, 61, 68

Tarquinian Tomb of Hunting and Fishing, 86, *86–87*, 88, 137n174

Tarquinius Priscus, Lucius, King of Rome, 76

Thales of Miletos, 94, 132n36

Theophilus, 117, 118, 140n247

Theophrastus, 46, 48, 74, 133n61

transparency of amber

 brilliance and, 41, 45, 132n44

 bubbles and, 37, 122–23

 color and, 51

 lyngourion and, 48

 magnifying property and, 38

 precious-metal settings and, 41, 132n45

 stringing / knotting systems and, 118

 in Verucchio tomb objects, 39

X

Xenocrates, 49

Published by the J. Paul Getty Museum, Los Angeles
Getty Publications
1200 Getty Center Drive, Suite 500
Los Angeles, California 90049-1682
www.gettypublications.org

Marina Belozerskaya, Editor
Kurt Hauser, Designer
Pamela Heath, Production Coordinator
Ellen Rosenbery, Photographer

Printed in China

Library of Congress Cataloging-in-Publication Data
Causey, Faya.
 Amber and the ancient world / Faya Causey.
 p. cm.
 Based on introduction to online catalogue of ancient
carved amber in the J. Paul Getty Museum.
 Includes bibliographical references and index.
 ISBN 978-1-60606-082-7 (hardcover)
1. Amber—Mediterranean Region—History.
2. Amber—Italy—History. 3. Amber—History.
4. Civilization, Ancient. 5. Mediterranean Region—
Civilization. 6. Mediterranean Region—Antiquities.
7. Italy—Civilization. 8. Italy—Antiquities. I. J. Paul
Getty Museum. II. Title.
 TS755.A5C38 2011
 553.8'79091822—dc22
 2011013719

Illustration credits

Every effort has been made to contact the owners and
photographers of objects reproduced here whose names
do not appear in the captions or in the illustration
credits. Anyone having further information concerning
copyright holders is asked to contact Getty Publications
so this information can be included in future printings.

Front jacket: Head of Female Divinity or Sphinx
 Pendant, Etruscan, 550–520 B.C. (fig.48)

Front flap: Addorsed Lions' Heads with Boar in Relief
 Plaque, Etruscan, 500–480 B.C. (fig. 33)

Title page: Necklace, Italic, 500–400 B.C. (detail, fig. 37)

p. 4: Prometopidion (horse forehead armor, detail),
 South Italian, about 480 B.C. Bronze, ivory, and amber
 eyes. Los Angeles, The J. Paul Getty Museum

p. 6: Standing Female Figure Pendant (detail, fig. 49),
 Etruscan, 525–500 B.C.

pp. 10–11: Baltic amber (detail, fig. 14). Private collection.

Back jacket: Piece of burning Baltic amber (fig. 30)